PLYMOUTH AT WAR

From Old Photographs

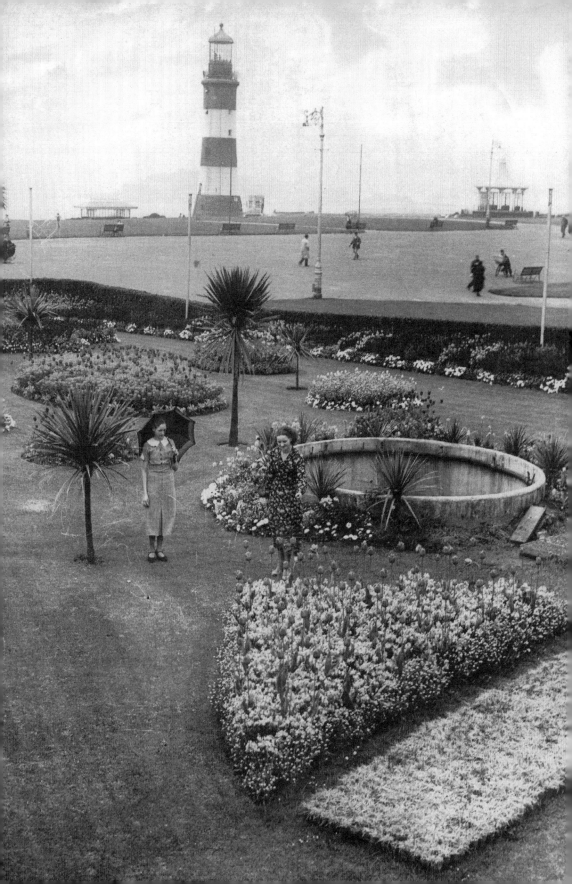

PLYMOUTH AT WAR

From Old Photographs

DEREK TAIT

AMBERLEY

Frontispiece: A pre-war view of Plymouth Hoe. The bandstand, which can be seen in the background, was removed for its scrap metal which was to be used as part of the war effort. It was never replaced. Two girls admire the tulips and, as this is Plymouth, one has an umbrella!

First published 2012

Amberley Publishing
The Hill, Stroud
Gloucestershire, GL5 4EP

www.amberley-books.com

British Library Cataloguing in Publication Data.
A catalogue record for this book is available from the British Library.

ISBN 978 1 4456 0425 1

Typesetting and Origination by Amberley Publishing.
Printed in Great Britain.

Contents

Acknowledgements

Thanks to the *Western Morning News* for letting me use their archive photographs. Many of these would have been taken by their staff photographers including Dermot Fitzgerald and Stanley Green.

Also thanks to Maurice Dart, Eric Webb, Steve Johnson, Jim Davis, Tina Cole, Ellen Tait, Alan Tait, Keith Parker, Sally Ware and Sam Mitchell for other photographs that appear in the book.

I would also like to thank Guy Fleming, Frank Wintle, Brian Moseley and Roy Westlake for their help and advice.

I have done my best to track down the owners of the copyright of all images used and apologise to anyone not mentioned.

Introduction

Plymouth today is a very different city to the one it would have been, due entirely to the Blitz of the Second World War. The city, perhaps, suffered the most from the total devastation dealt out by the Luftwaffe in 1941.

The American magazine *Life* reported in its pages at the time that 'Plymouth is worse than it looks' and it looked pretty bad. London, Coventry and Bristol suffered severe damage during the war but all agreed that Plymouth was in the sorriest state with much of the centre completely obliterated.

Amazingly, Plymouth thought itself, at one time, to be so far away from military attacks and hostility that it would escape the heavy bombing it endured. The dockyard was an ever-tempting prospect to the Germans though, as were the railways and fuel depots.

It's hard to imagine the lively, bustling city of Plymouth before the bombs dropped because so much has now changed and been rebuilt. Plymouth in 1940 was a busy city with cars, buses and trams all running side by side. Shops, cafés and restaurants overflowed with customers.

The first bombs fell on the city on 6 July 1940 when houses at Swilly Road, Devonport were hit. There were several casualties.

In later attacks, shelters in the city centre would be crowded with shoppers and one store even served coffee as the bombs fell. Air Raid Wardens would clear the streets of people who refused to take cover.

It's hard to imagine a time when the sound of an air-raid alarm would have you rushing out of your house down into the garden to take cover in a purpose-built Anderson shelter. Imagine a time when food, clothing and other essentials were all rationed. Imagine having to take a gas mask with you everywhere you went in fear of an enemy attack.

Civil defence forces were brought together and did a great job. These included fire fighters, first aiders and of course, the Home Guard. The Home Guard wasn't a ragtag bunch of men as featured in 'Dad's Army' but were a well-trained force, ready to deal with any eventuality. Air-raid control centres were based underneath the Guildhall and also beneath Devonport market. They proved to be the nerve centres during attacks.

The heaviest attacks on the city came in 1941. In the two intensive attacks on the 20 and 21 March, 336 people lost their lives. Five further attacks in April brought the toll to 590.

There was hardly a building in Plymouth that wasn't touched in some way by the Blitz. Much of the city centre was obliterated, and although many buildings remained among the debris, most were damaged beyond repair.

It's hard now to imagine the total devastation the bombing caused. Many of the most popular streets, Bedford Street, Union Street, Old Town Street, Frankfort Street, Cornwall Street, George Street, etc., were either totally destroyed or severely damaged. Major buildings such as the Guildhall, the Municipal Buildings, St Andrew's Church, Charles Church and the General Post Office were obliterated.

Many schools were also hit. These included Plymouth High School for Girls, the Hoe Grammar School and the infants school at Summerland Place. Many churches were destroyed also including St James the Less, King Street Methodist, St Peter's, George Street Baptist and many more. The bombing was indiscriminate and destroyed anything that got in its way.

In the dockyard the bombing was bad but not as damaging as would have been thought, and within a few months, it was back to 90 per cent efficiency.

Outside the city, the bombing was just as devastating and areas affected included Devonport, Stonehouse, St Budeaux, Swilly and Saltash Passage. Devonport lost many buildings including the Post Office, the Alhambra Theatre, the Synagogue, the Hippodrome and the Salvation Army Headquarters.

Residential houses that were either destroyed or beyond repair amounted to 3,754. Others that were seriously damaged but able to be repaired amounted to 18,398. Houses that were slightly damaged amounted to an additional 49,950.

It's hard to imagine today, unless you've lived through it, such devastation to a city.

Many children were packed off to live with relatives, friends or obliging families in safe areas in the countryside. Thousands left on special trains and many saw it as an adventure while others were upset to leave their parents behind. Lady Astor said at the time, 'What helped the evacuation was that everyone seemed to have a cousin in the country!'

News of the devastation of Plymouth soon reached the rest of the world and gifts arrived from all over, particularly the United States, who sent ambulances, soft toys, food packages and surgical dressings. The Royal Sailors Rest received crates of supplies so large that they were unable to get them into the building.

At the end of the war, there were a total of 4,448 casualties due to the raids and heavy bombing of the city.

Throughout it all though, the people of Plymouth remained strong and there were regular dances on the Hoe almost in defiance of the enemy as they bombed the city.

Plymouth was reborn after the war and the city was rebuilt almost from scratch. Few buildings remained in the heart of the city that were there before the war, and even now, the city is constantly changing.

Here, in over 200 photographs, is a brief look at what the city and its people were once like.

One

Pre-war Plymouth

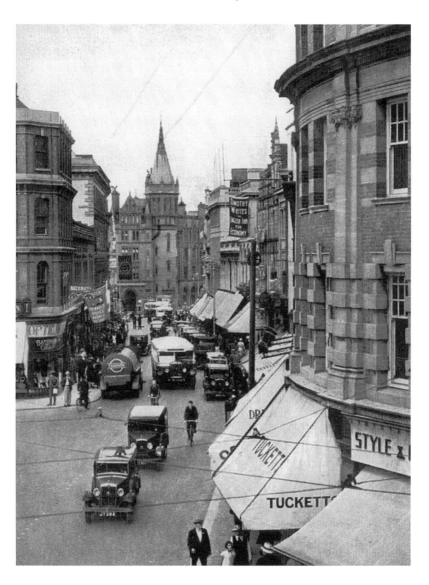

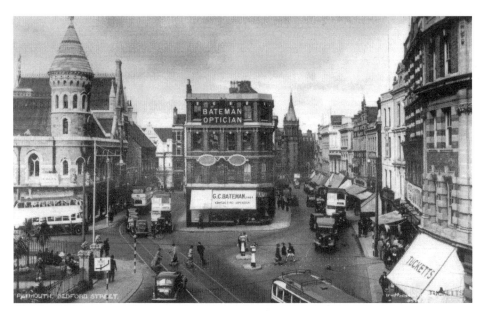

Bedford Street. A 1940s shot of pre-blitzed Bedford Street and Basket Street. On the right, can be seen Tucketts and in the centre of the picture is Bateman's Opticians with their trademark pair of large spectacles. Bedford Street was a busy thoroughfare at the time and cars, trams and buses can all be seen in this scene running side by side.

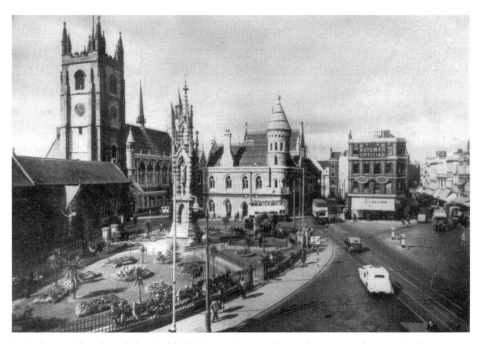

St Andrew's Church and the Guildhall. Shown here with its pleasant garden area leading across the tram lines to Bedford Street. On 20 March 1941, the building was damaged severely but not thought to be beyond repair. However, on 22 March, the church was hit again leaving only the walls and tower still standing.

Uglow's advert. Uglow's Café was a popular place for refreshments situated in Lockyer Street. Ideal on your way to or from the Hoe. The building had previously housed the YWCA. Lockyer Street also housed an ARP shelter and a first aid post during the war. The Prince of Wales Hospital in Lockyer Street was bombed but was later reopened.

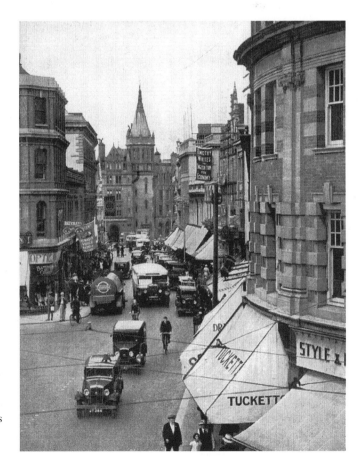

Bedford Street. Timothy White's can be seen in the background. Timothy White's was a hardware, homes and gardens store. Their flag reads, 'The English Firm for Economy!' On the left is Bateman's opticians. A flag behind Bateman's eerie pair of eyes sign reads, 'Listen! His Master's Voice – Radio and Records'.

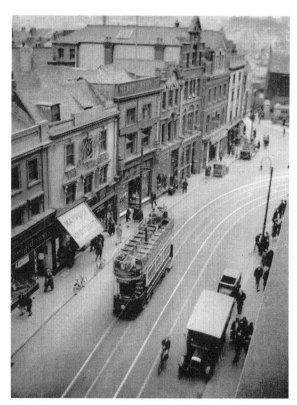

The Boots store in Old Town Street. Boots had two shops in the town, this one was open day and night. Their other shop was in George Street. The awning besides Boots reads, 'Maypole For Butter and Tea'. Also close by is the Frigidaire shop and Henry Lawry Ltd.

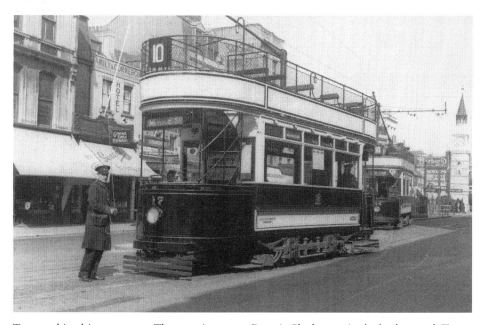

Tram and its driver *c.* 1930s. The tram is near to Derry's Clock, seen in the background. Trams were a popular site in pre-war Plymouth and they continued to run until 1945. This was an ex-Torquay Tramways car and had a short life from between 1933 to 1936.

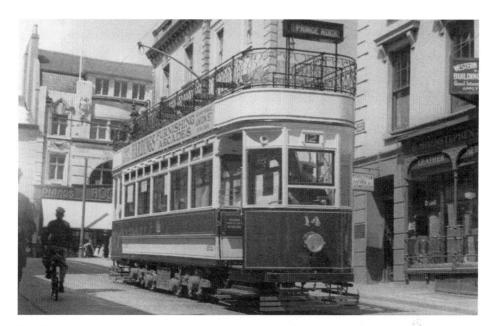

The Number 14 to Prince Rock *c.* late 1930s. Also an ex-Torquay car, this one lasted until 1942. This one has an advert for Hardings Furnishing Arcades on the side. This tram is pictured in Chapel Street, Devonport, outside the premises of G. Mounstephen and Son – Leather Merchants.

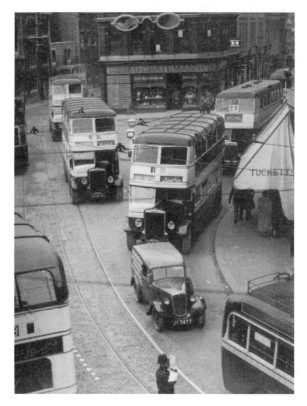

A policeman directs the traffic at the junction of Basket Street and Bedford Street. Directing the busy traffic at this junction could be a hectic job at the best of times. The policeman guiding the traffic here was once known as Punch because of his red, hooked nose though he was said to be popular with everyone.

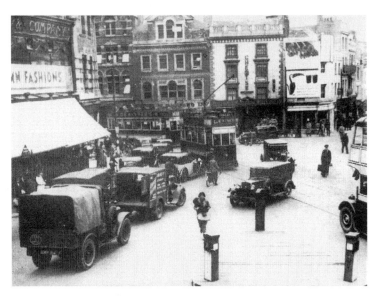

The busy junction at Old Town Street and Bedford Street known as
Spooner's Corner c. 1937. Spooner's can be seen in the left of the picture
announcing, 'Autumn Fashions'. This was a major site of bomb damage on
20 March 1941. On a billboard in the background can be seen the famous
Guinness toucan. Balkwill's the chemists can also be seen in the middle of
the picture.

Underwood's tea and groceries advert. The leading and largest tea and
grocery suppliers in Plymouth. Situated in Bedford Street, the building was
known as Trelawney House and the upstairs was said to be haunted by the
late Squire Trelawney.

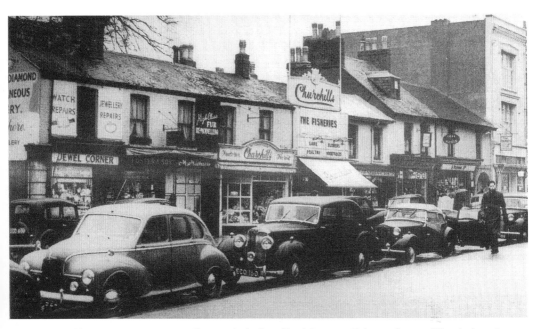

Westwell Street *c.* 1940. Westwell Street linked Bedford Street to Princess Square. The city's main post office stood in this area opposite Guildhall Square. The land was bought for the Post Office in 1881 and the main building was expanded in 1904. Badly bombed the area was cleared away and part of it later became Armada Way.

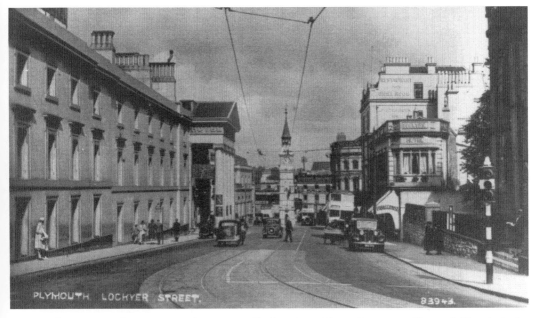

Lockyer Street. The street started at Derry's Clock and was the main route to Plymouth Hoe. At its far end, before stepping onto the Hoe Promenade, there was an ornate gateway. Lockyer Street was the home of the YMCA's main hostel in the city. It was hit in the Blitz of March 1941 and several people lost their lives.

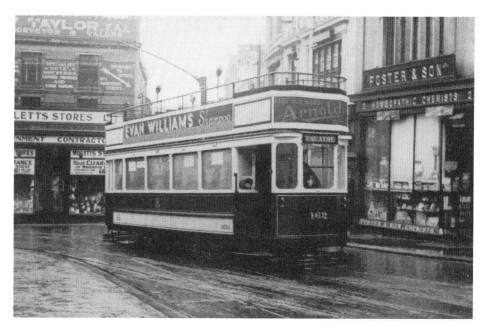

A tram passing Courtenay Street. This was one of the sixteen cars built at Milehouse by the Tramways Department. These survived until 1942 though car 153 was damaged in the Blitz. Pictured outside Fosters and Sons, 'The Homeopathic Chemists'. In the background can be seen the Milletts store.

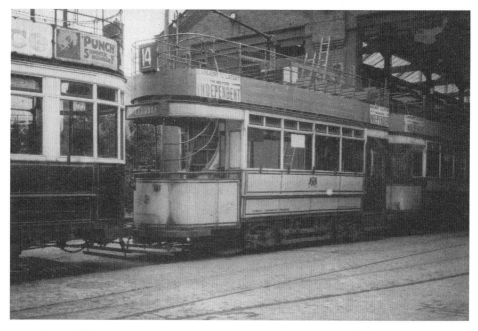

Trams at Milehouse. The middle tram was an older tram from the 1920s and the livery is the original primrose yellow. These were later repainted in standard corporation colours and were a common site around Plymouth. The trams carry adverts for *Punch* and the *Independent*.

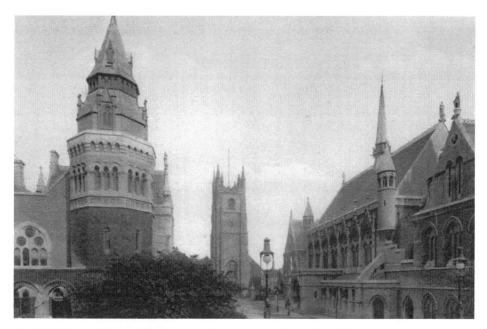

Guildhall Square. The Guildhall managed to survive the first night of the Blitz but was very badly damaged by the bombing of 21 March. It was to be demolished but the council decided to rebuild it in 1951.The work started in 1953 and the building was completed in 1959. It was reopened by Field Marshall Montgomery.

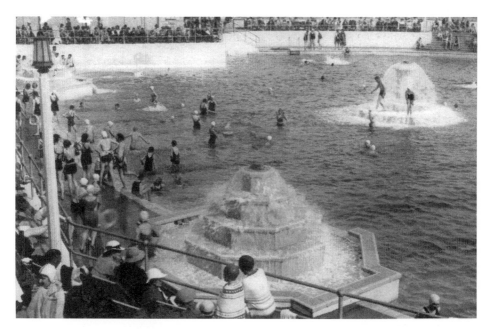

The Lido. The pool was opened on 2 October 1935 by the Lord Mayor, E. W. Rogers. Construction work was carried out by John Mowlem & Co. Ltd and Edmund Nuttall Sons & Company. A brass band played to welcome the thousands of people who turned up for the event. Not much chance of getting a swim that day!

Plymouth Hoe. The scene of several bomb attacks with the Pavilion Café, the Pier and the Bandstand totally destroyed. The Pavilion café stood back from Drake's statue joining Hoe Road and was a very popular meeting place. The café was run by E. Dingle and also by Goodbody's during the 1930s.

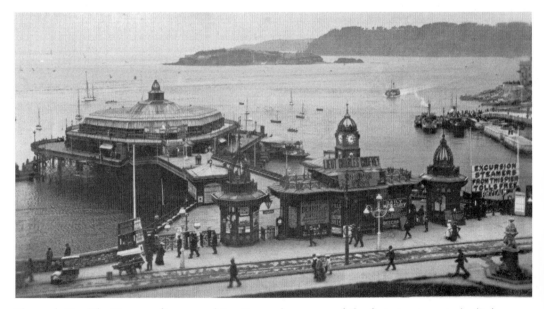

Plymouth Pier. The Pier was first opened in 1870 and was one of the first structures to be lit by electricity. It was destroyed by bombing though its remains were not cleared away until 1953. Before the bombing, interest had been waning in the Pier and it was steadily losing money. In its heyday, it had been a major attraction in Plymouth with swimming contests, concerts, dancing and boat trips.

Two

Bomb Damage

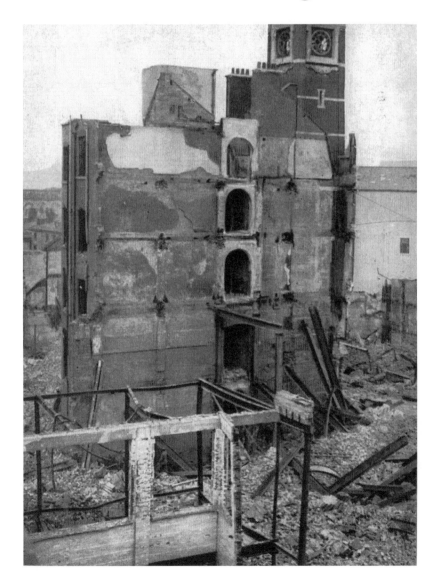

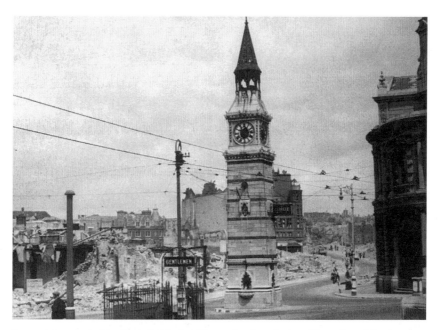

Instantly recognisable, Derry's Clock still stands after the bombing of 20 March 1941. The Bank Chambers, now the Bank Public House, still stand but the Royal Hotel was totally destroyed. The sign fixed to the right of Derry's Clock says, 'To the Hoe' and points towards Lockyer Street.

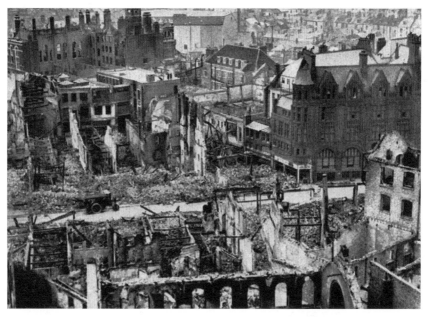

Looking towards George Street and the Prudential Buildings. The *Western Morning News* building can be seen in the background. The building survived mainly because it had only been built two years previously and was made with solid, fire proof building material. There was an underground bunker for the workers beneath the building.

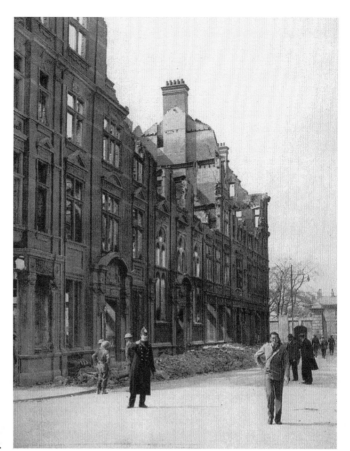

A policeman directs people away from the Royal Sailors' Rest at Fore Street, Devonport. Three men from the Civil Defence survey the damage in the background. The building was better known as 'Aggie Weston's'. With its destruction went 777 beds which had been occupied each night since the beginning of the war. The canteens and kitchens there had provided 2,000 meals every day.

Boots advert. Boots proved to be vital to the war effort. Three million lbs of saccharin was produced by Boots (equal to 731,000 tons of sugar, a rationed commodity) and 1,500 tons of chloramine was manufactured, for water sterilisation in Europe, Africa and the Far East. Up to 7,000 Boots employees all over Britain fought in the war and by 1945, 381 had been killed in battle or in air raids.

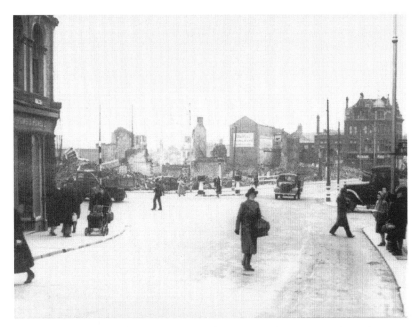

Drake Circus. On the left, among the rubble, are signs directing people to their new premises, probably nearby or, to Mutley which was to become the main shopping area after the bombing of Plymouth. Mutley had lost out to the shops of the busy city centre but after the Blitz, it became the city's primary shopping centre and home of many destroyed businesses.

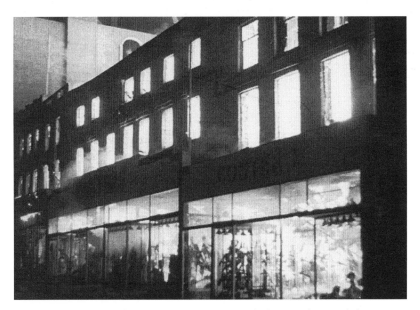

Costers store in Frankfort Street. Costers was a clothing and general department store. They were well known for their school uniforms. One of their adverts at the time read, 'Back to School Offer: Boys Suits, 8 Shillings and 11*d*'. That would be about 44p nowadays!

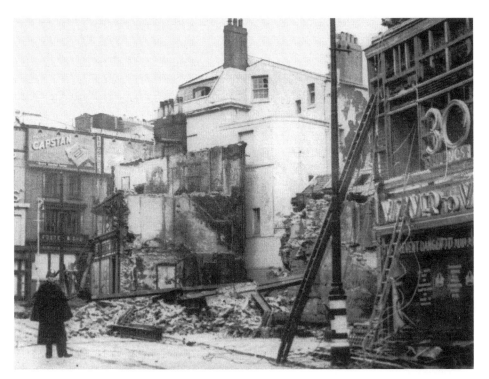

A policeman surveying the damage in Union Street. The badly-damaged shop on the right is 'Weaver to Wearer', the 30s tailors. They also had a shop where the old Criterion Cinema had been in Cornwall Street. On 27 January 1941, there was a huge explosion at Coxside when an attempt to reconnect the gas supply was unsuccessful. Three men were killed and five were injured and ominous bulges were noticed in Union Street caused by broken gas mains.

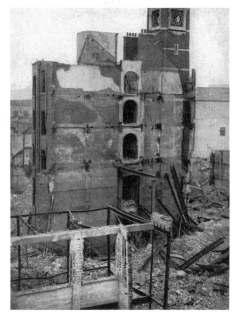

Plymouth Co-operative Society's headquarters in Frankfort Street. The Society was originally formed in 1859 by ten tradesmen. The premises on the corner of Frankfort Street and Courtney Street was a major landmark in the City Centre with a clock tower, standing 120 feet. When the building was bombed on the night of 21 March 1941, only the tower, shown here, and parts of the walls remained.

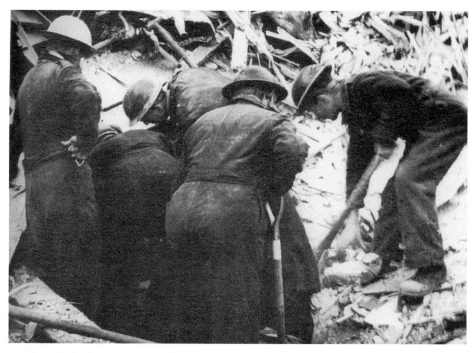

Searching for bodies among the rubble. During the raids of 20 and 21 March 1941, 336 civilians were killed. The further heavy bombing in April resulted in another 590 being killed. On top of this, thousands were injured. Many people were reported missing and no trace of them was ever found.

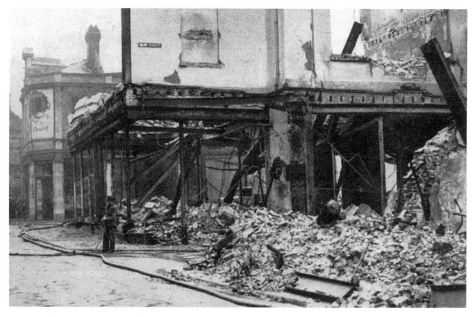

Cornwall Street. After the Blitz, Ivor Dewdney was the first shop to be built in the new Cornwall Street. Their first pasty shop before the war was at 2 King Street. Shops in the old wrecked Cornwall Street became known as bungalow shops because there was nothing upstairs!

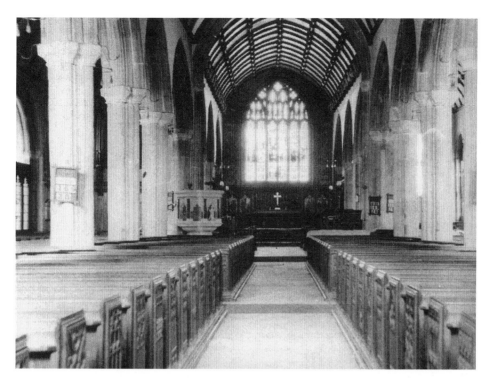

St Andrews Church before the bombing. St Andrew's had stood on the site for almost 900 years. It was the bells of St Andrew's that Sir Francis Drake had heard on his return to Plymouth in the sixteenth century after his voyage around the world. Although the bells survived the Blitz, there was a ban on them ringing except as a warning of invasion. This ban was eventually lifted in 1943 and once again the bells rang out to welcome worshippers.

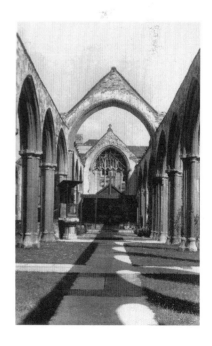

St Andrew's Church. The church is shown here after being bombed. St Andrew's Cross, outside, was thought to be unstable and was demolished as being unsafe. The main chancel became a garden until the church was rebuilt and flowers were planted around the pillars. It was reconsecrated in 1957.

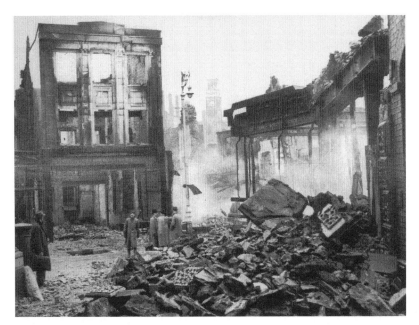

Looking towards George Street from George Place. Some very official men look around in disbelief at the remains of the city. The building in the background belonged to the American Shoe Company. George Street was a main thoroughfare of pre-war Plymouth.

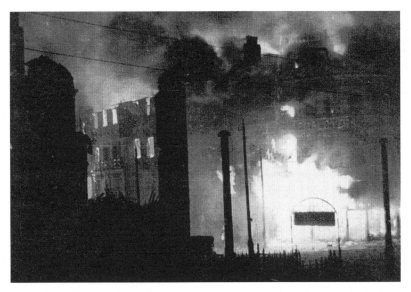

By Derry's Clock on the junction of George Street and Bank of England Place. The sign in the foreground, illuminated by the fire behind, stood above the underground toilets. Derry's Clock was, before the war, considered to be the centre of Plymouth. All trams and buses terminated nearby. It was also a well-known meeting place and it was said, 'marriages may be made in Heaven but in Plymouth, they're arranged under Derry's Clock!'.

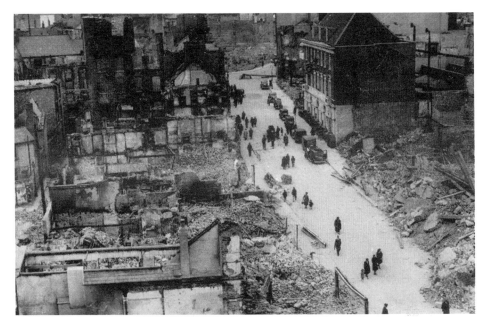

The *Western Morning News* building can be seen on the right hand side of the picture. Next to it are the remains of the Costers building. Although the *Western Morning News* building survived, its photographic department was destroyed and many photographs of pre-war Plymouth were lost forever.

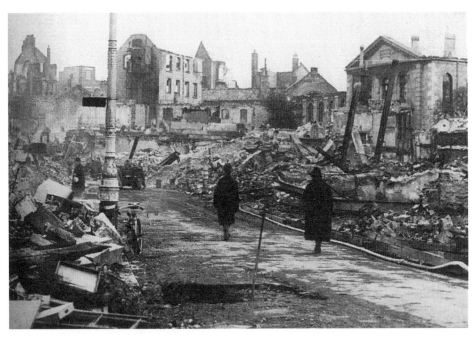

George Street. Such was the unbelievable heat that thick plate glass windows melted in pools onto the pavement. Gold in a jeweller's shop turned to liquid and trickled away. Tins of meat and soup exploded and where they were packed together, they fused into lumps of molten tin.

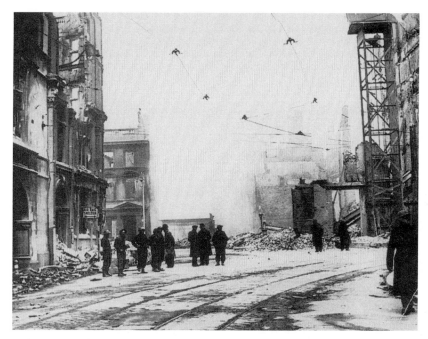

Perkins Corner by Bedford Street. Notice the overhead tram cables and the tramlines on the road. A sign on the left of the picture points to an air-raid shelter. The air-raid shelters survived the bombing but were later destroyed during demolition.

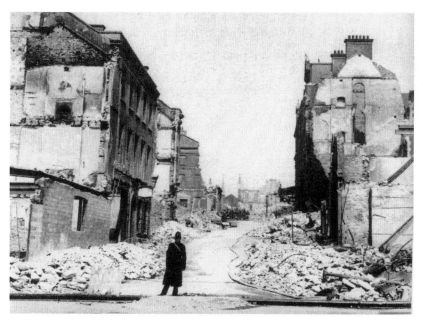

Tavistock Street off Fore Street in Devonport. The Alhambra Theatre is on the right. The Alhambra opened on 19 April 1924, though the building had housed many places of entertainment before dating back to 1894 when it was originally known as the Empire Theatre.

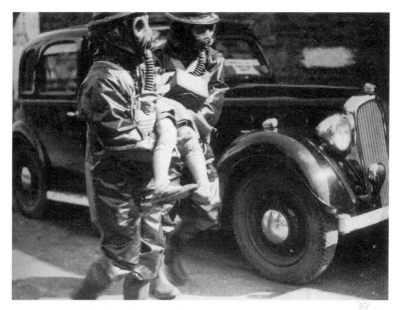

Gas mask rescue drill. Everyone carried gas masks with them in case of an enemy gas attack. Luckily, they were never needed. A stall in the market would inspect and repair the masks. Amazingly, gas masks were also available for horses and dogs!

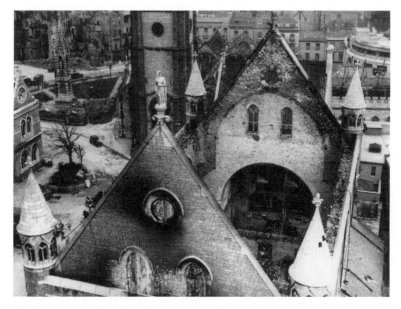

The burnt-out Guildhall, with St Andrew's Church in the background. Opposite the Guildhall, in Guildhall Square, stood the ornate Municipal offices. Inside was the Lord Mayor's chambers, the borough treasurer's offices and the town clerk's office, as well as the Plymouth School Board. The Mayor's chambers were decorated with maps, paintings and an original portrait of Sir Francis Drake. The Guildhall Square area was opened by the future King Edward VII in 1874 and destroyed in the bombing of March 1941.

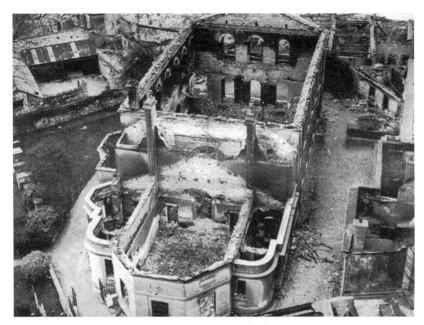

George Street Baptist Church. The church was tucked away behind the busy main shopping thoroughfare and dated from 1649. Many other churches were destroyed in the bombing including Courtenay Street Congregational Church, the large King Street Methodist Church, the Greenbank Methodist Church and the Sherwell Congregational Church as well as many others around the city.

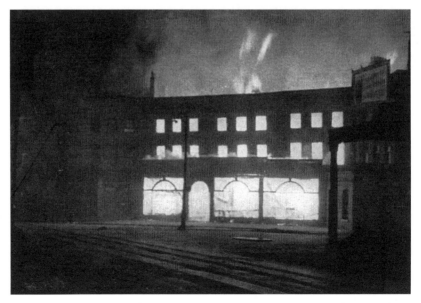

Jay's Furnishing Stores, The Octagon, Union Street. On 21 March 1941, large parts of Union Street were bombed and the entire Octagon was ringed with fire as Jay's and Service & Co.'s premises burnt. Further back, in the Crescent, the hotels, Westminster and Hackers were completely destroyed.

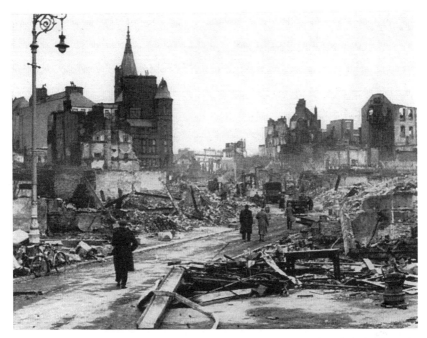

George Street. On the left is the Prudential Building, later demolished when the reconstruction of the city took place. The Prudential opened in 1903 on the corner of Frankfort Street and George Street. On the right is the shell of the George Street Chapel.

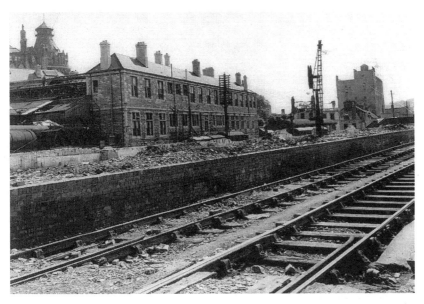

Millbay Station showing the old goods shed *c.* 1941. The passenger station is on the left and in the background can be seen the Duke of Cornwall Hotel. Many railways all over Plymouth were bombed to cause maximum disruption. Others hit included those at St Budeaux, Devonport and Millbay.

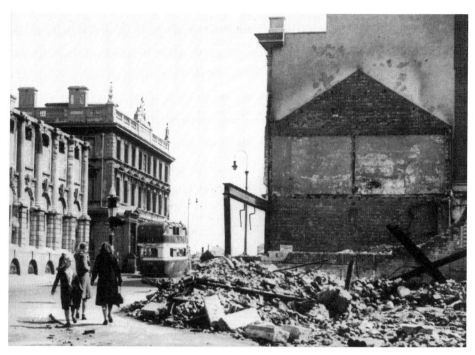

Turning into Bedford Street from George Street. A destroyed store lies in a pile of rubble while the pattern of the building can be seen on the remaining structure. A double-decker bus is still running in the area while pedestrians make their way through the debris.

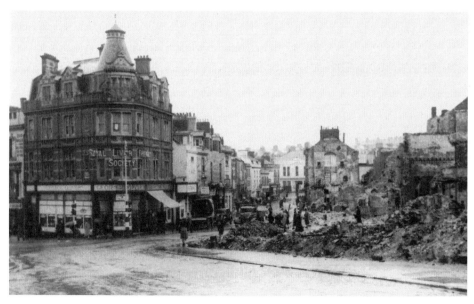

Bedford Street and Cornwall Street. The building on the left housed the Royal Liver Friendly Society. Underneath were the premises of George Oliver. Few major buildings survived the Blitz. Among them were the Odeon in Union Street, The Prudential Building, the Pannier Market and the offices of the *Western Morning News*.

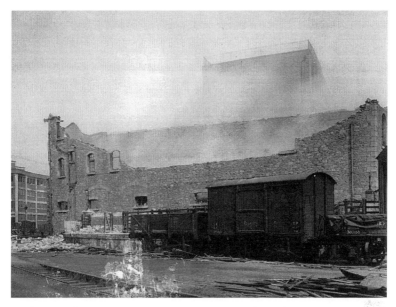

Millbay Docks. Here the smouldering remains of number 86 store. On the night of 23 April, there were fifty-six fires throughout the city. These covered Millbay Docks, Cattedown, Victoria Wharves, Torpoint Oil Depot and many others. Water dams containing 5,000 gallons of water each were erected at nine different points.

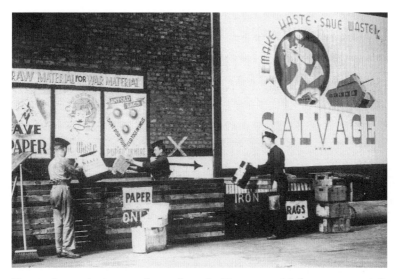

Navy salvage. A sign on the wall reads, 'Raw material for war material'. Everything was saved and here, Navy personnel sort items into containers marked, 'Paper', 'Iron' and 'Rags'. Anything that could be salvaged was and if possible, it was used again. Railings were taken away from many homes and buildings around Plymouth to be used for armaments. Unfortunately, they were never used and you can still see where these were cut away and never replaced on some of the older buildings around the city.

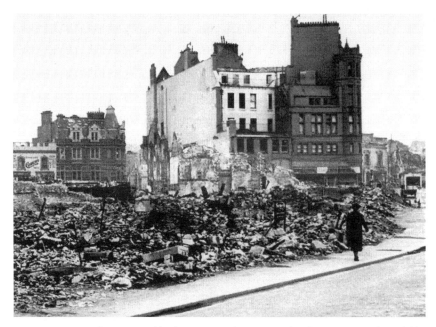

George Street. Cohen's in Bedford Street can be seen in the distance over the rubble. Plymouth had 602 alerts altogether and 59 raids in which bombs were dropped. The bombing started on 6 July 1940 and the last bombs fell on 30 April 1944.

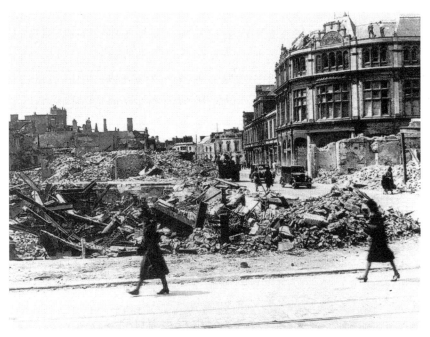

East Street to Old Town Street with the Corn Exchange on the right. Old Town Street survived the first wave of bombing but was subsequently totally destroyed. The heaviest death tolls from enemy bombing came during the raids of March and April 1941 when the total number of civilians who lost their lives amounted to 590.

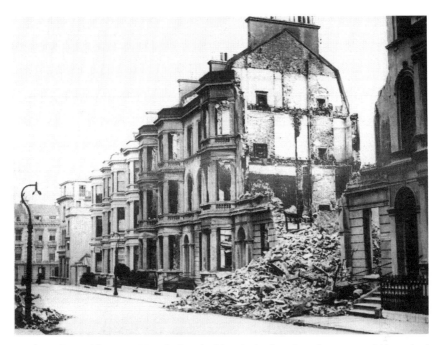

Leigham Street, The Hoe. Heavily bombed but in its day, these houses would have had spectacular views across the Sound to Mount Edgcumbe and Jennycliff. The Forte Post House now stands where they were situated. Leigham Street adjoins Citadel Road.

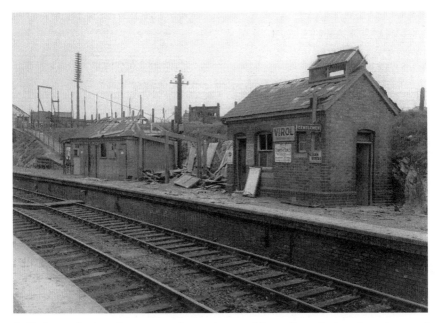

St Budeaux Station. A very popular station used by sailors, dockyard workers and tourists travelling to work and to Cornwall over the Royal Albert Bridge. A target for the Luftwaffe being not far away from the bridge and other strategic targets such as the armaments barges and the nearby dockyard.

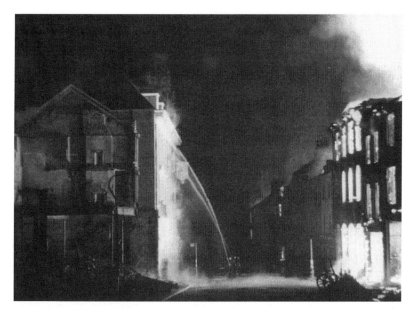

The *Western Morning News* Offices. Here firemen hose down the building besides Costers to stop the fire from spreading. The *Western Morning News* building was built of newer materials and withstood the blasts. After the war, New George Street was built around it.

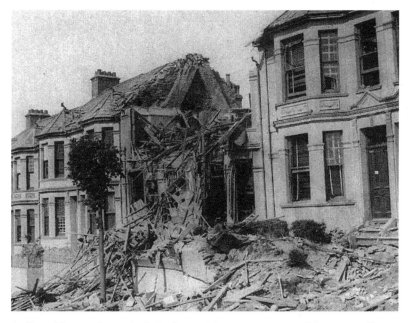

A direct hit on a house in St Budeaux. Many gaps appeared in streets all over Plymouth like this one after bombing and after the war, when houses were rebuilt, a sometimes more modern building appeared in the space. These can be seen all over Plymouth with a mismatch of terraced Victorian homes and sometimes a 1950s bungalow in the middle!

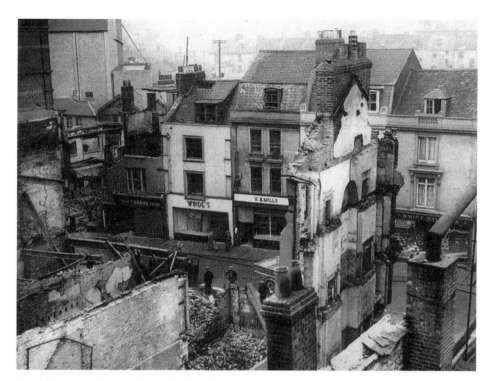

Frankfort Street. V. B. Mills and Wride's shops can be seen in this photograph as two men help to clear away the rubble. To the right of the picture would have stood Leicester Harmsworth House and the remains would have been Costers.

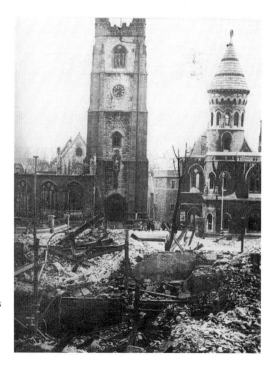

St Andrew's Church from Spooner's corner. The word *Resurgam*, which is now carved in stone above the main entrance of the church, was first chalked on a piece of wood and fixed to the lintel of the ruined church by a Miss M. E. Smith. She was headmistress of the Kindergarten at Plymouth High School for Girls. *Resurgam* is Latin for, 'I shall rise again'.

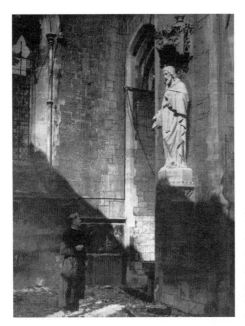

St Peter's, Wyndham Square. Preb G. B. Hardy, the Rural Dean of Plymouth, surveys the damage and a statue that has escaped the bombing. The church was much more modern than others in Plymouth and it had a rich collection of ornaments and vestments. It was gutted by fire but its distinctive tower remained in place.

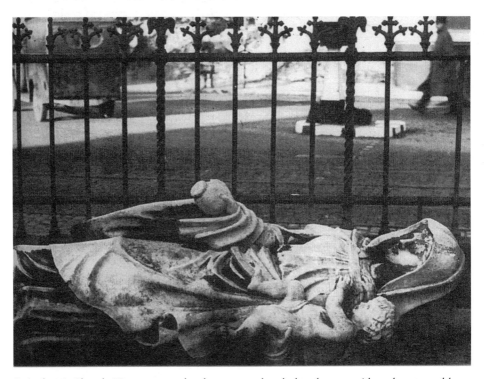

St Andrew's Church. Here, a statue has been rescued and placed to one side to be restored later. After the church was bombed, the debris was removed and the church, with its simple altar and gleaming cross, continued to welcome worshippers, while birds flew in and out from where the roof had once been. The organist, Dr Harry Moreton, led the singing in the now garden church while the congregation gathered around what had once been the body of the church.

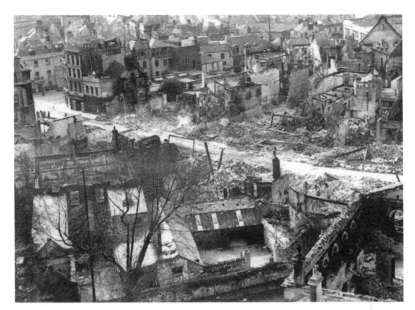

This photograph shows some of the devastation that was felt all over Plymouth. Here, many buildings still stand but most are damaged and would become victims of later bombing raids. All over the city, bomb disposal squads worked coolly and efficiently dealing with the many unexploded bombs. At Osborne Place on the Hoe, one large bomb was being removed on a lorry when it exploded killing five men.

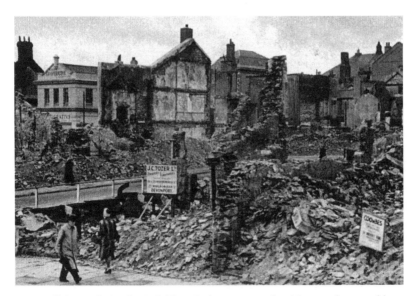

Cornwall Street. A sign for J. C. Tozer Ltd announces that it's moved to an address in Devonport. Signs like these popped up all over the city directing customers to their new locations. Some businesses spread out all over the city and could be found trading in any available premises including houses. In the background can be seen the Co-operative building.

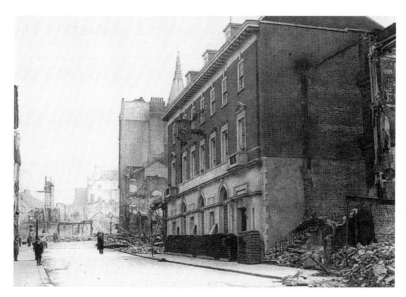

The *Western Morning News* building. It was a proud record of the proprietors that they never once stopped printing the *Western Morning News* or the *Western Evening Herald* throughout all the difficulties and dangers of the enemy attacks. The building had then recently been rebuilt using newer materials and while many of the older buildings perished this one withstood the bombing.

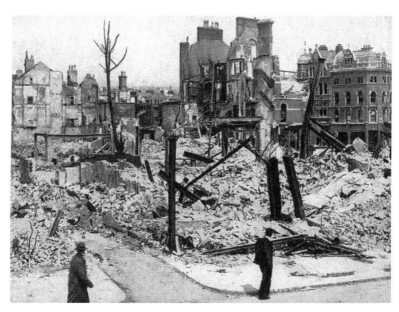

Across from Spooner's Corner to the top of Treville Street. A few twisted girders can be seen sticking up from the rubble. Fire was responsible for much of the damage to the city. Many of the fire brigades which rushed towards Plymouth from other cities during the fierce attacks, found that their hoses wouldn't connect to the hydrants. The fires were so numerous that most had to be left to burn themselves out.

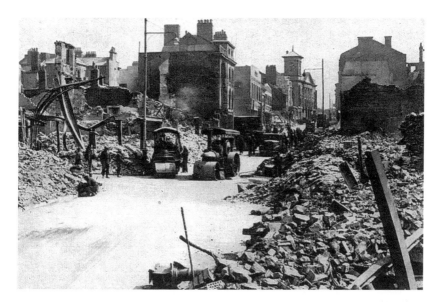

Fore Street, Devonport. Two steam rollers can be seen in this picture helping with the clearing up of the main street. Badly damaged in the raids of April 1941, Fore Street lay in ruins together with the adjacent areas of Marlborough Street, Tavistock Street, Catherine Street, Queen Street and High Street. Buildings such as the Belisha Hall, the Hippodrome and the Alhambra Theatre were totally destroyed.

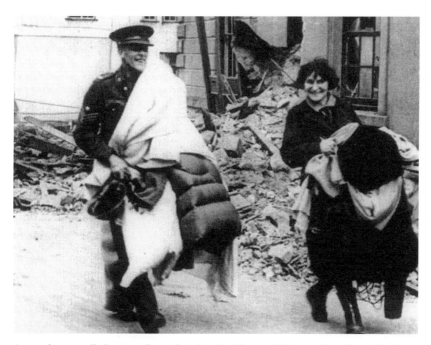

A couple save all they can from their bombed house. This consists of mainly sheets and blankets. With many of the large stores which supplied the bulk of food and clothing destroyed, supplies were short and were rushed to the city from other parts of the country.

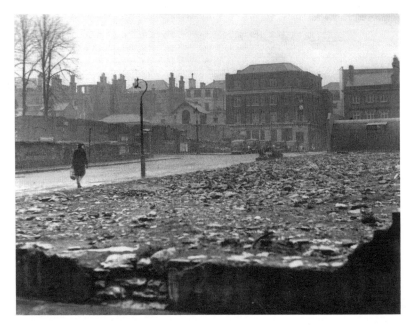

Phoenix Chambers in Princess Square. The devastation of Plymouth was worse than anyone could have imagined in the early days of the war. There wasn't a part of the city that escaped the attacks and scarcely a house in the area didn't experience some form of damage either serious or minor.

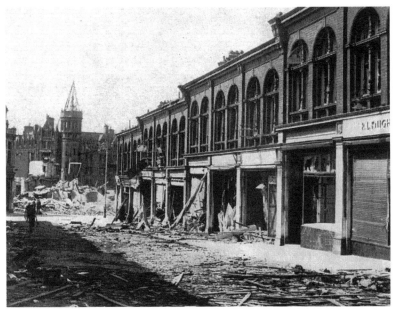

Market Avenue. The five nights of heavy raids in April 1941 covered 23 hours and 16 minutes of continuous bombing and 1,140 high explosive bombs were dropped together with thousands of incendiaries. Altogether, 1,500 homes were demolished or destroyed beyond repair while another 16,500 were left damaged.

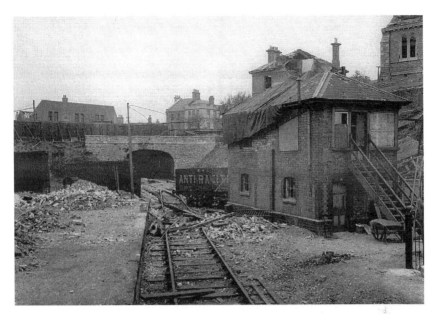

Devonport Station pictured on 30 April 1941. Bricks and pieces of wood can be seen here strewn across the tracks. In the background, a house has a large hole in its roof. On 14 and 15 March 1941, six bombs fell on Central Park with two near to the Southern Railway at Devonport. Five people were killed in the bombing attacks and seven houses were demolished when six bombs fell on Royal Navy Avenue in Keyham.

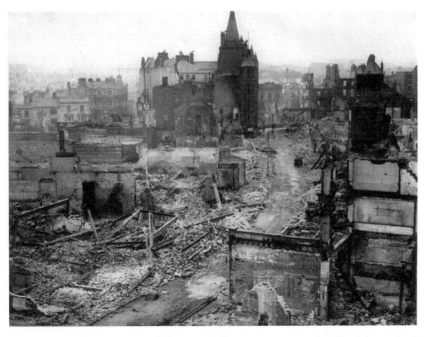

George Street. Goodbody's had shops in both George Street and Bedford Street, both of which were completely destroyed. Other cafés that became victims of the Blitz included the Mikado, Williams, the Hoe Tea Pavilion and Spooner's.

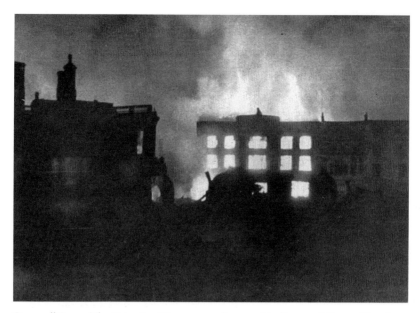

Cornwall Street. The Criterion Cinema was destroyed in Cornwall Street. Elsewhere in the city, there were many other picture houses lost. These included the Palladium, the Cinedrome, the Electric, the Devonport Hippodrome, the Forum in Fore Street (later repaired), the Savoy, the New Empire, the Tivoli and the Grand in Union Street. It seems amazing now that the city housed so many cinemas but this was a time of few televisions.

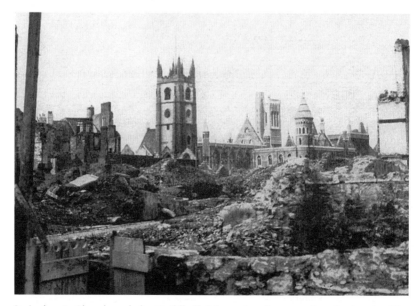

St Andrew's Church and the Guildhall. Many churches were lost in the city. The main ones, apart from St Andrew's were Charles Church, St Saviours, St James the Less, St Peter's, All Saints, St George's, St Aubyn and St James the Great as well as at least ten others.

44

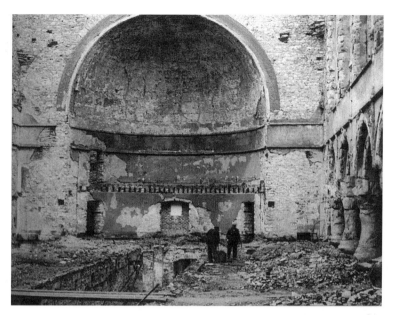

Plymouth Guildhall. Here, it's possible to see the total devastation caused to the inside of the Guildhall. On 21 March 1941, the Guildhall, St Andrew's Church and the Municipal buildings were gutted by fire after intensive bombing and although the Guildhall was earmarked for demolition, it was eventually rebuilt and reopened in 1959.

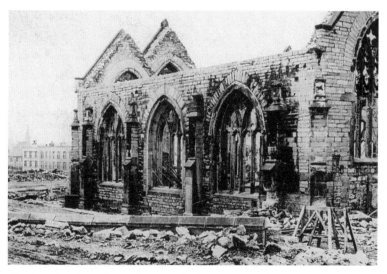

Charles Church, still standing at Charles Cross roundabout as a memorial to Plymouth's war dead. Charles Church was situated in Vennel Street until the area was obliterated by heavy bombing. The Council's reconstruction committee decided to demolish the church on 15 June 1953 but it was saved and on 1 November 1958, the Reverend J. Allen James dedicated it as a memorial to the 1,200 civilians who lost their lives in the war. Alderman G. Wingett, the Lord Mayor, unveiled a plaque on the north wall.

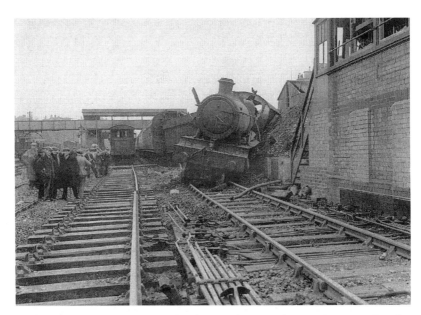

Keyham Station *c.* 1941. On 29 April 1941, the GWR locomotive 4911, *Bowden Hall*, was paused during an air raid when a bomb fell so near to it that it was damaged beyond repair. Keyham Station was adjacent to Saltash Street and Admiralty Street and was opened in 1901.

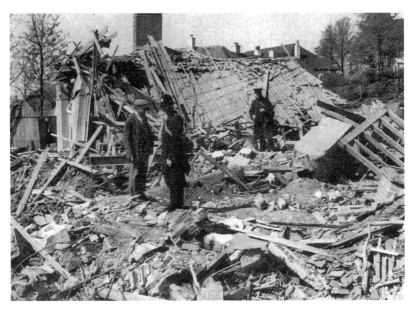

Bomb damage at Pomphlett. Here a direct hit has demolished someone's home. On 7 May 1941, the residents of Pomphlett had a narrow escape when a bomb destroyed three houses and damaged fifteen others. Three people were killed, however. They were the Reverend W. Spencer, a Naval man and a Plymouth businessman. Elsewhere in the city, bombs were dropped on Millbay, Thorn Park and Stoke but there were no casualties.

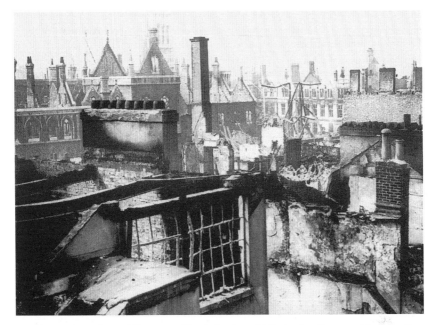

Premises in East Street. The post office is in the middle in the distance. After the Post Office was destroyed, it moved to new premises at Spears Corner in Tavistock Road. East Street ran from Cornwall Street to Old Town Street and backed onto the market.

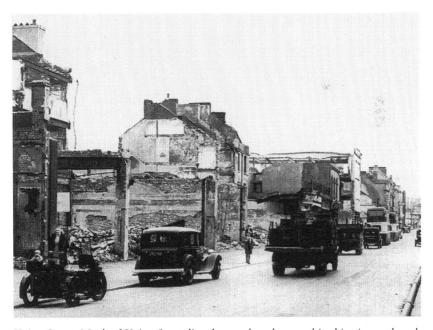

Union Street. Much of Union Street lies shattered or destroyed in this picture though the road has been cleared of debris so that traffic can still flow through. On the right, is a temporary gas supply pipe running along the kerbside. The railway ran right over an arch at the top of Union Street and this and the nearby Millbay Station became a target for bombing.

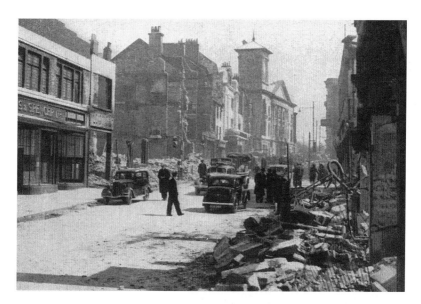

Fore Street, Devonport. Once a very bustling area, over 100 businesses lined the street from Granby Barracks to the Dock Gates. These included Woolworth's, Timothy White's, Lipton's and Marks & Spencer's, which can be seen on the left of the picture. As well as a dozen hotels or pubs, there were also three cinemas. These were The Forum, The Tivoli and The Electric.

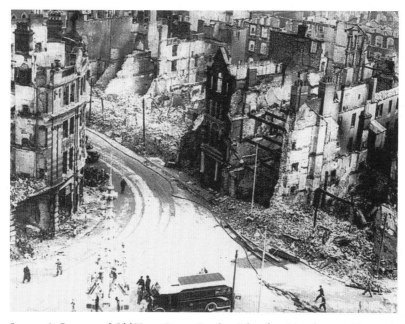

Spooner's Corner and Old Town Street. On the night of 20 March 1941, Plymouth experienced some of its heaviest bombing and the first big fire in the city was at Spooner's. Facing St Andrew's Church, it had been a main feature of Plymouth for many years. The whole area became a huge furnace and despite the efforts of firemen, it was impossible to save.

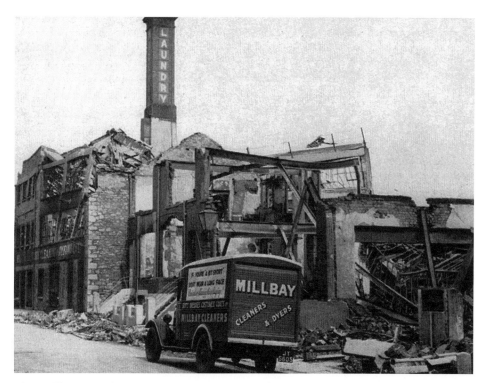

The Millbay Laundry, Stonehouse. The laundry had an air-raid shelter underneath in a reinforced basement. Millbay was a target not just because of the train station but also because of the nearby docks. It was the Germans' aim to disrupt life as much as possible by disrupting supplies and travel.

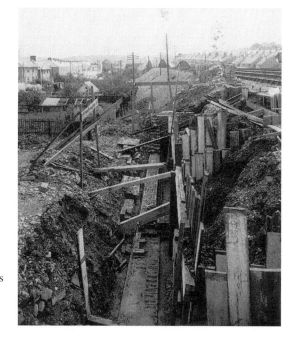

St Budeaux west box foundations. On 28 April, the bombing raids centred mainly on Devonport, Bull Point, St Budeaux and Camels Head. Altogether, there were forty-two fires but the damage wasn't as extensive as it had been in the attacks of previous nights when large areas of the city had been destroyed.

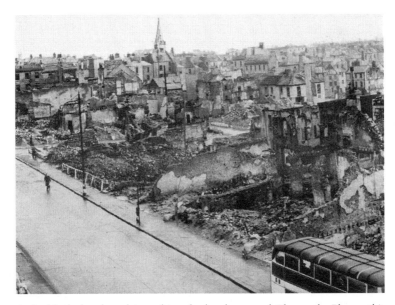

A double-decker bus drives through the devastated Plymouth. Plymouth's first alert was on 30 June 1940. The air raid lasted an hour but there were no incidents. However, the next raid on Plymouth on 6 July 1940 saw the first enemy bombs fall on Plymouth. These were dropped shortly before noon on eight houses at Swilly Road, Devonport. A man, a woman and a boy were killed and six people were injured.

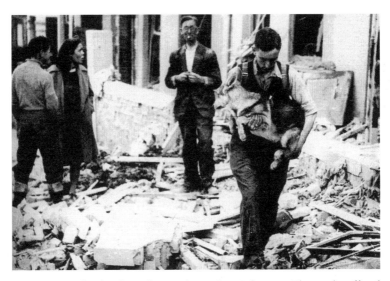

A man rescues his dog from the wreckage. On 7 July 1940, Plymouth suffered its second serious attack. A German bomber flew low over the east end of the city towards Laira. The plane was so low that a man working at the gasworks opened fire on it with a shotgun. The gasworks were the target but the stick of bombs fell on South Milton Street and Home Sweet Home Terrace. A policeman and a soldier on duty in the area were killed by the blasts together with five other people.

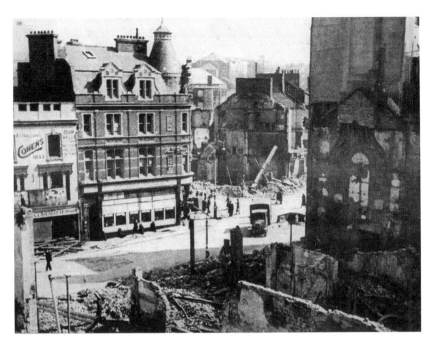

Cohen's of Bedford Street. Bedford Street, before the war, would have had spectacular Christmas grottos at Dingles, Yeos, Pophams and Spooners. The whole street and area would be very busy and each shop would have had highly-decorated window displays and their own Santa Claus.

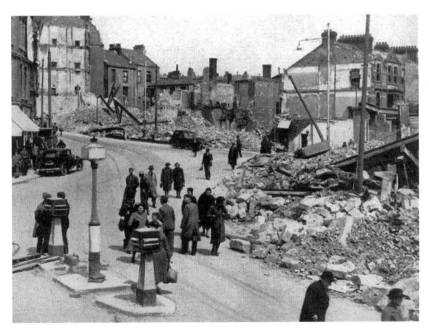

Drake Circus. The building on the left housed the Liverpool Victoria Insurance Offices. A huge hoarding advertising Bovril covered the right-hand side of the building. Many of the buildings still standing would later be torn down for redevelopment.

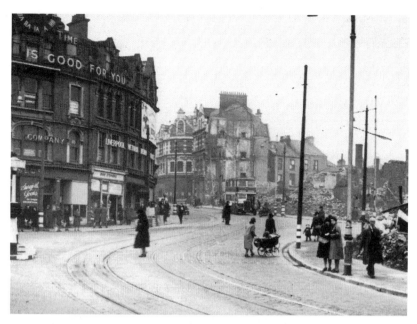

Drake Circus and the Guinness clock. The clock had, 'Guinness Time' written underneath and then their motto, 'Guinness is good for you' in large letters. Here, people go about their everyday business after the main streets have been cleared of debris.

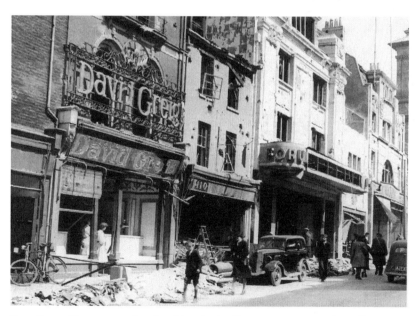

Fore Street, Devonport after bombing in April 1941. Here, people walk around the rubble outside David Greig's. Just further up the street is the Forum Cinema. Further bombing in the Devonport area on 9 July 1941 resulted in the deaths of two policemen who were sheltering in one of the few remaining doorways in Fore Street. Seven other people were injured and eight people were trapped underneath a demolished house. They were later rescued safely.

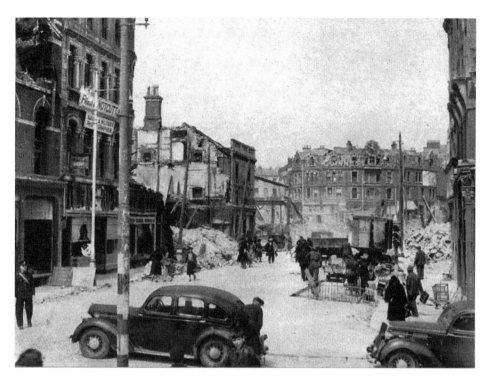

Old Town Street was severely damaged on 20 March 1941 and the Luftwaffe returned the next day to finish the job. Here, the street is being cleared of debris so it can be opened up to pedestrians and traffic. On the left, is Fred Notcutt's the photographers and further down the street can be seen the Guinness building.

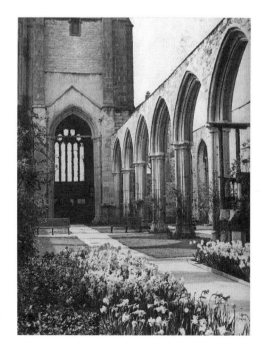

St Andrew's Church showing the daffodils that grew there while it was a garden church. St Andrew's was opposite the bustling Bedford Street. The bust of Zachariah Mudge, within the church, stood intact despite the earlier heavy bombing.

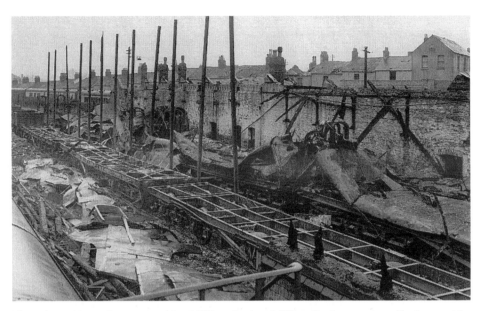

The Belmont Street line approaching Millbay Station. Millbay Station was severely damaged by the bombing of March and April 1941 and was closed on 23 April 1941 after which the platform lines were only used for goods traffic loading.

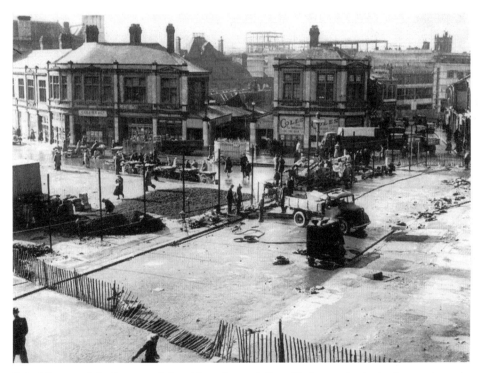

Rebuilding work in the area of the old market and Corn Exchange. In the background can be seen Collier & Co. and Coles. This later picture shows many of the old buildings of Plymouth still standing but reconstruction has started in the background.

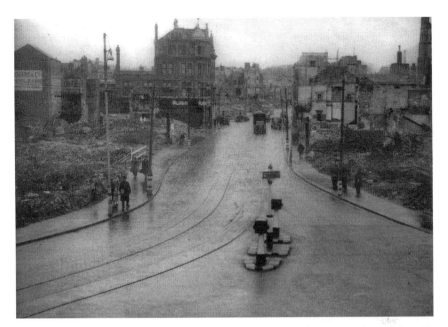

Old Town Street to Drake Circus. The Burton building can be seen in the middle with Roger's & Co. on the left. An Army truck heads down the road while a family, complete with gas masks, head towards what remains of the shopping centre.

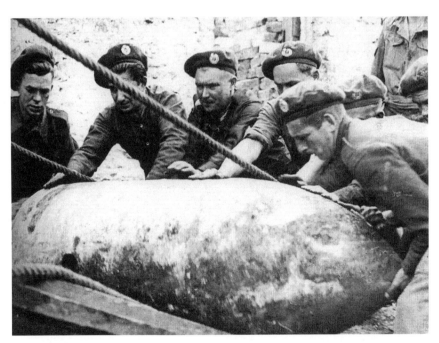

Bomb disposal. Sam Mitchell who lived at Cotehele Avenue remembers coming out of the air-raid shelter by the Astor playing field after five bombs had exploded nearby. A warden stood above an unexploded bomb with his legs astride it while guiding everyone away with his hands. Luckily, it didn't explode.

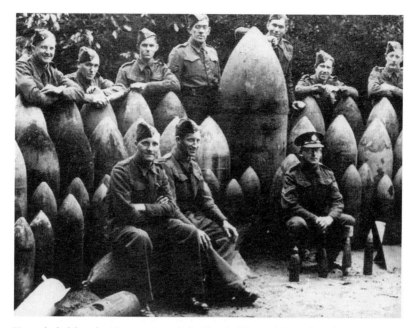

Unexploded bombs. Brave men of the Bomb Disposal Squad sit here among a few of the many bombs that dropped on Plymouth but failed to go off. From the time France fell to Germany in June 1940, the Germans had closer aerodromes to Britain from where they launched their attacks on the South West. This made Plymouth a much easier target for them.

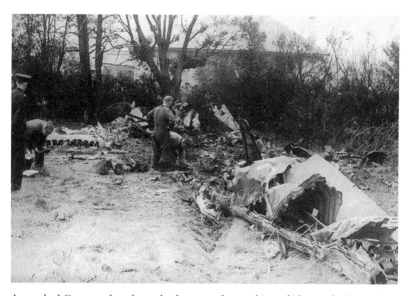

A wrecked German plane brought down on the outskirts of Plymouth. On 14 June 1943, an enemy plane, a Junkers 88, crashed in the garden of a house at Stoke. The house was used as a hostel for the WRNS. This was the first time that an enemy plane had actually crashed within the city. The crew were killed and were later buried at Weston Mill cemetery with full Air Force honours.

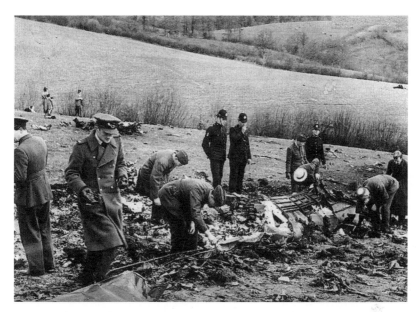

German plane crash. On 24 November 1941, a Polish fighter brought down a German plane over Plymouth. The four crew members successfully baled out. One of them was wounded and had been pushed out over Plympton while the others were taken prisoner near Bickleigh. The plane crashed near to Roborough and the wreckage spread out over two fields.

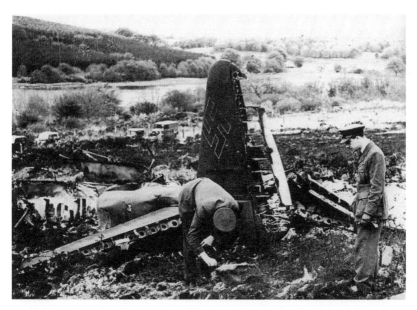

A German plane shot down on Dartmoor. On 18 August 1941, a single German bomber was shot down by the Royal Marines. It had been a wet and windy night and the visibility was poor. The plane was hit by anti-aircraft fire and crashed in flames at Gawton Wood near Bere Alston. All four members of the crew were killed and the plane crashed violently into the woodland and exploded.

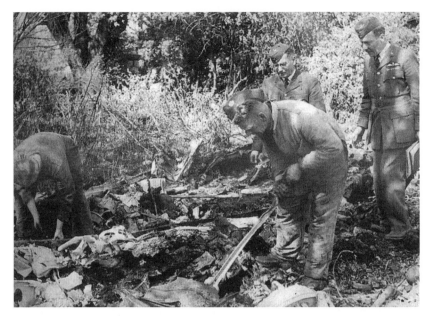

German plane wreckage being examined. On 25 September 1940, there were numerous dogfights between German raiders and our own planes. Shells seemed to be bursting everywhere and it was the most spectacular daylight fight that Plymouth had seen. People came out in the street to watch and the heavy barrage made many of the raiders flee, dropping their bombs aimlessly in the Sound.

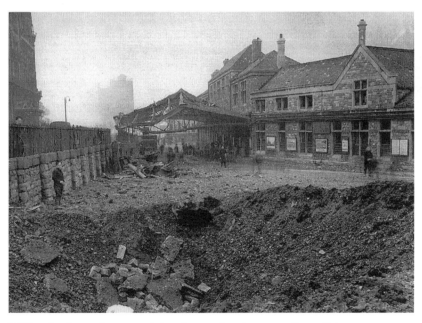

Millbay Station at the east end showing two bomb craters. On 14 February 1941, ten enemy planes attacked the city. Bombs fell on Stoke and on Millbay. One fell on the roadway outside the Continental Hotel where there had been a large dance. The Hotel was badly damaged but luckily there were only a few casualties.

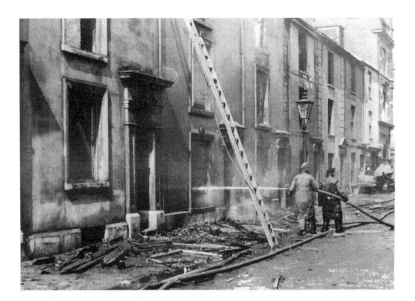

Homes in George Street, Devonport. On 8 July 1940, Plymouth had its third serious raid in the early morning. Four bombs were dropped on Devonport in the vicinity of Marlborough Street and Morice Square. A local butcher, Mr Slee, was killed when his shop took a direct hit. Three other people were seriously injured and another seven suffered less serious injuries. Three of the bombs fell near to the Royal Albert Hospital but there was little damage.

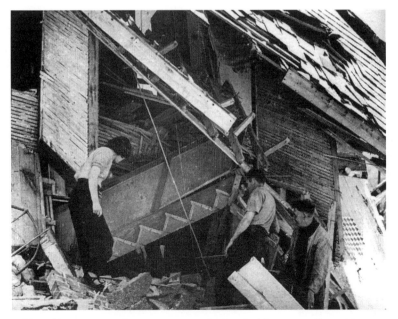

A blitzed house. Here three occupants of a bombed house see if anything can be salvaged. Quite often, there would be nothing to save and many people not only lost their homes but also their possessions and sometimes even their livelihoods.

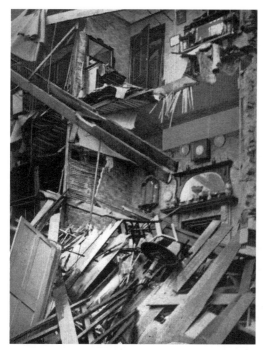

A house on Old Town Street. Amazingly although this house has been blown to pieces, the pictures and plates have stayed, unbroken, on the walls. There were many incidences like this where fragile items survived the blasts while everything around them was destroyed.

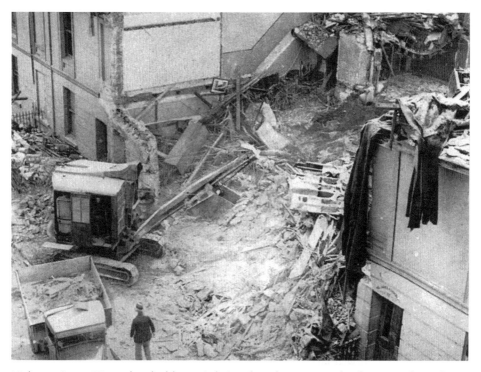

Mulgrave Street. Here a bombed house is being cleared away to make the area safe. Mulgrave Street joined Lockyer Street at one end and at the other end it joined Athenaeum Street, which led upwards towards the Hoe.

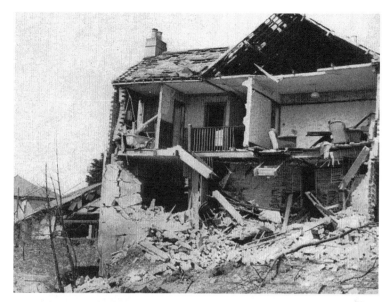

A house in St Budeaux. Here a house is severely destroyed, the target probably being the Brunel Bridge. On an earlier raid in the area on 28 August 1940, six bombs and several incendiaries were dropped in the countryside between St Budeaux and Crownhill. Incendiaries which threatened the woodlands were quickly dealt with by the Auxiliary Fire Service while the bombs fell away from houses and did no serious damage.

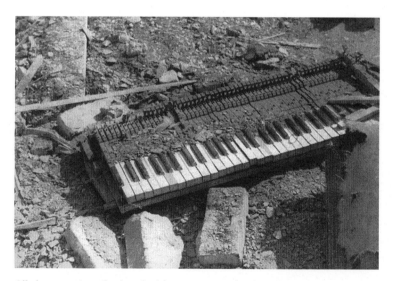

All that remains of a bombed house. Here a keyboard from a piano is the only remnant left. On 25 September 1940, there was a day of alerts with bombs dropped at Higher St Budeaux and near to Higher Ernesettle Farm. Luckily, there were no casualties. Another bomb was dropped on Agaton Fort wounding two soldiers. On the same day, bombs fell on Prison Hill at Mutley, and houses at Goschen Street, Keyham where five houses were destroyed and several others damaged.

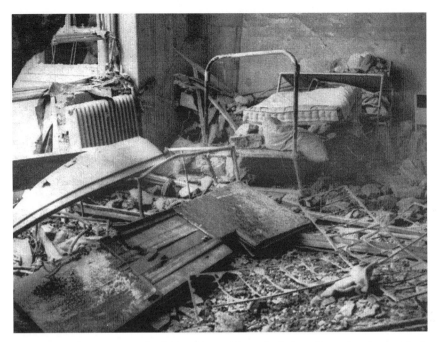

City Hospital, Maternity Ward. Bombing raids took their toll on the city hospitals and many casualties had to be cared for in adapted premises outside the city. Hardly a hospital in the city escaped damage. Those affected included Royal Naval Hospital at Stonehouse, Greenbank, Lockyer Street and Devonport, the Royal Eye Infirmary at Mutley and the Isolation Hospital at Swilly.

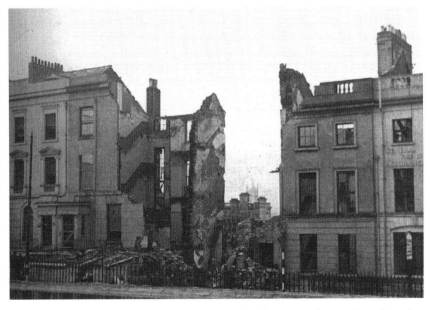

Athenaeum Terrace. A huge part of the terrace has been ripped away by a direct hit. On the right of the picture are the offices of General Assurance. Athenaeum Terrace adjoined Millbay Road close to the Crescent.

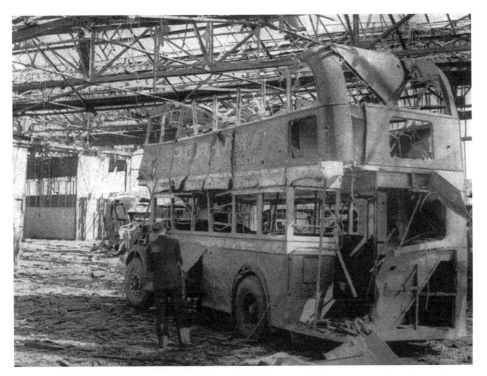

The Western National Bus Depot at Prince Rock. On 30 April 1944, the bus depot received a direct hit. Three fire watchers sheltering there were killed and sixteen people were seriously injured. There was severe damage to the depot and several of the buses were totally destroyed.

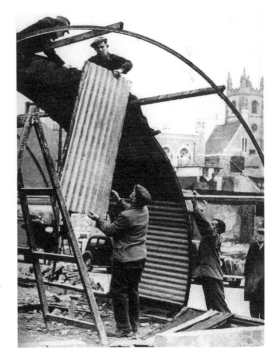

Improvised Nissan huts. It would be many years before there were enough premises to house all of the city's traders and Nissan Huts sprung up all over the centre as a temporary measure. These were small, cramped and damp but served their purpose.

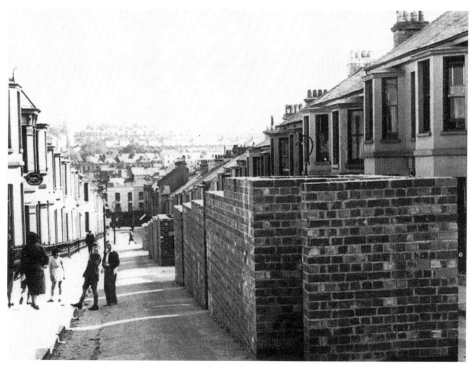

The public air-raid shelters in King's Gardens. Many homes had their own shelters which were erected in their back gardens. These Anderson shelters were made of corrugated iron and were issued free to people earning less than £250 a year. People with higher incomes had to pay £7. They were first issued in 1939 and undoubtedly saved many lives.

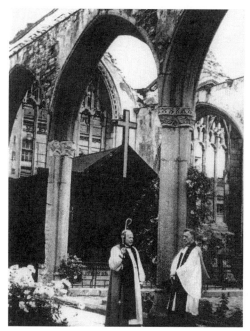

Many churches in Plymouth found themselves open to the skies like this one. Their walls had withstood the blasts thanks to them being made of solid stone, but their roofs perished. Services continued to be held in some despite this, while others were moved to smaller venues.

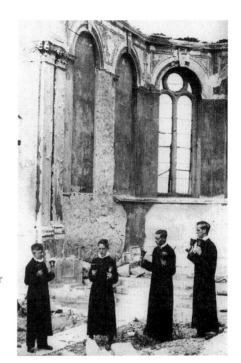

Handbells being rung in the remains of St George's, Stonehouse. St George's Church was located in Chapel Street in East Stonehouse. After the church was damaged by bombing, later services were held at St Paul's Church in Morice Square, Devonport. In 1957, the council bought the church for £1,400 and the stonework was used to build the Lady Chapel at St Gabriel's Church in Mutley.

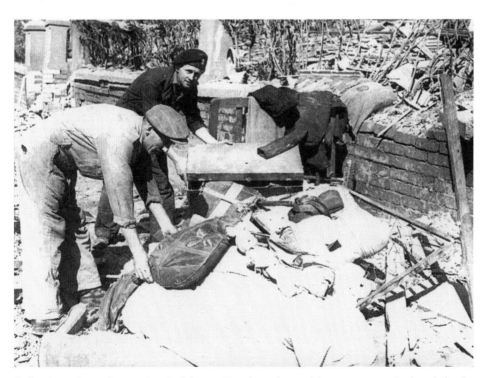

Collecting salvage from a bombed home. Regular salvage drives were organised to help the war effort. Tin, rubber, iron, steel, paper, cooking fat and even silk stockings were all collected. A popular poster during the war read, 'Salvage saves Shipping'.

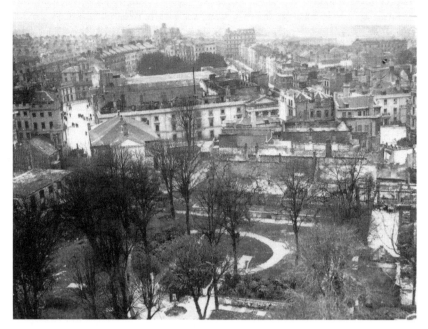

Westwell Gardens. The gardens were nearby to Westwell Street and were built over an ancient cemetery. The gardens were later removed when the reconstruction of Plymouth began. Interestingly, the bodies were removed under darkness so as to not upset the residents of Plymouth.

Fire at Lloyd's Bank, Bedford Street. Many of the major banks had their premises completely destroyed. These included Barclays in Princess Square, Lloyds and National Provisional in Bedford Street and the Midland in Bedford Street and Union Street.

Stonehouse Bridge. The bridge was first opened in 1773 and in 1828 the bridge was raised so that Hackney carriages could provide a public service from Plymouth to Devonport. Here, part of it is severely damaged by a nearby bomb blast.

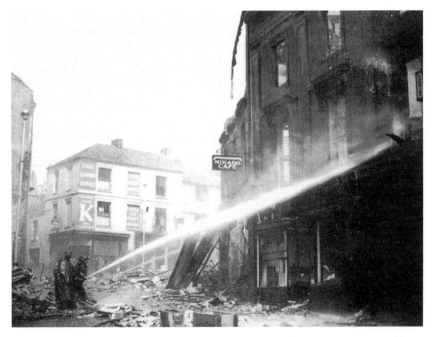

The Mikado Café in Old Town Street. Fires burned all night in Drake Circus and here, grocers try to put out the flames. In the background was K shoes whose sign read, 'Foot comfort service' and situated nearby was Spear's chemist.

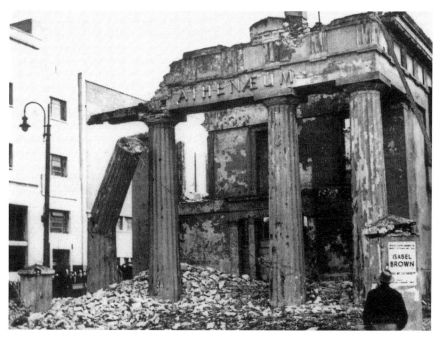

Demolition of the Athenaeum. The Athenaeum had its foundation stone laid on 1 May 1818. The building was designed by John Foulston. The building was destroyed by the bombing of 21 April 1941 though it partly remained standing until after the war when it was completely demolished in early November 1959.

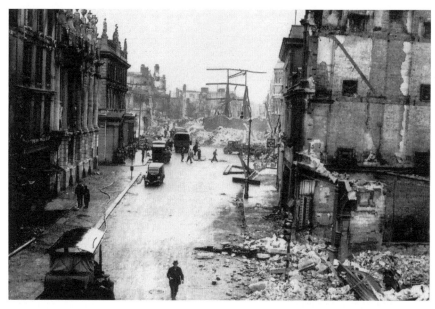

Bedford Street viewed from the Prudential Building. Here the road is being cleared further along so traffic can get through. The girders at the end are from the island between Bedford Street and Basket Street. The tower of the Municipal Offices is visible on the right with Bank Street on the left.

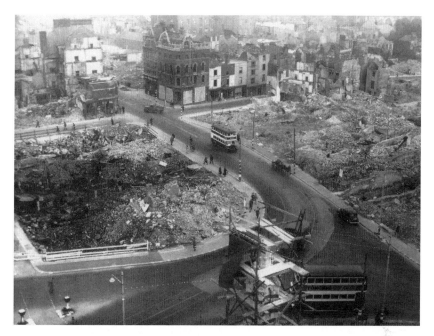

Taken from St Andrew's Church in the direction of Charles Church. Most of these old buildings, at the top of Old Town Street, would eventually be pulled down to make way for the new main post office. The patch of land on the right would eventually become St Andrew's Cross roundabout.

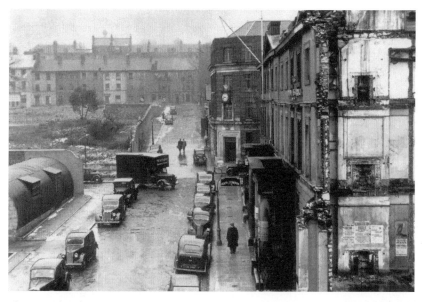

Phoenix Chambers at Princess Square. The chambers housed public offices including the collector of income and land tax. It was entered from Notte Street, Westwell Street, Princess Street and Lockyer Street. On 25 September, 1945, the council approved the erection of temporary shops at Princess Square to house the many businesses whose premises had been lost in the Blitz.

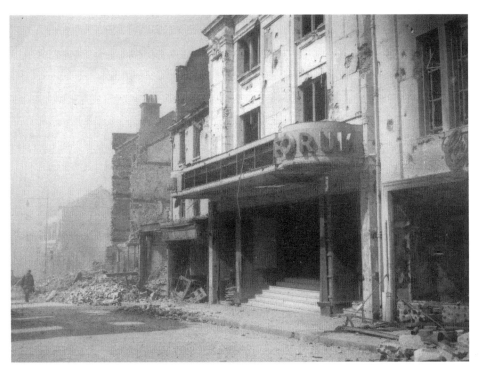

The Forum Cinema, Devonport. The Forum was severely damaged but later rebuilt and is now a bingo hall. Winston Churchill was later to address a Conservative rally at the Forum in 1950 and although five years after the end of the war, it still looked in a sorry state.

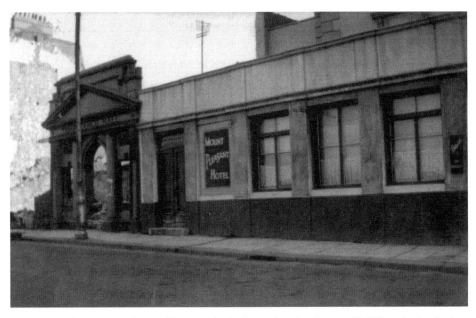

The Mount Pleasant Hotel in Millbay Road. The heavy bombardment of Millbay Station had an effect on many of the buildings around it. The Mount Pleasant Hotel was just across the road from the station and nearby to the Duke of Cornwall Hotel, which survived the blasts.

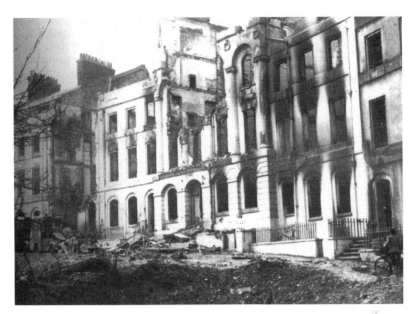

The Crescent took a direct hit and a large part of it was destroyed. This was later rebuilt. Opposite the Crescent was a hospital burial ground which was later made into a shrubbery and garden. The area was reputed to be haunted. Many years later, the Westward Television studios were built on this land.

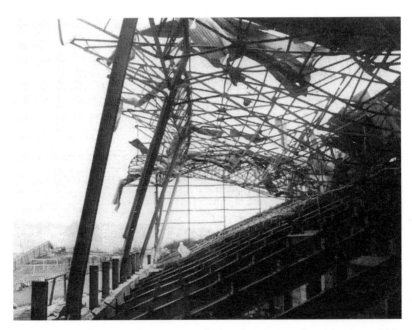

Plymouth Argyle's ground at Home Park. Another victim of a night-time raid in April 1941. The ground was thought to be a safe area, so much so that a large amount of furniture and pianos salvaged from peoples homes was stored there. Unfortunately, these were all destroyed in the fires that engulfed the ground. The site was thought to be less vulnerable because it was away from the City Centre.

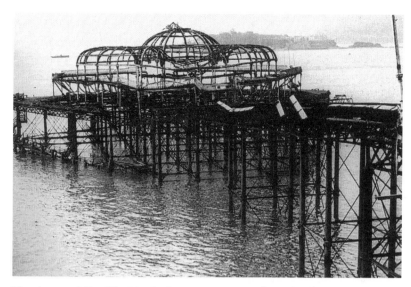

The destroyed Pier. The Pier looks in a sorry state here after being destroyed by the many bombs that fell on Plymouth in 1941. The blitzed pier remained until the end of 1952 when the Council announced that they wanted to get rid of it as soon as possible. Interest had been waning in the Pier in the years running up to the war and there was no suggestion of rebuilding it in the plans underway to reconstruct Plymouth.

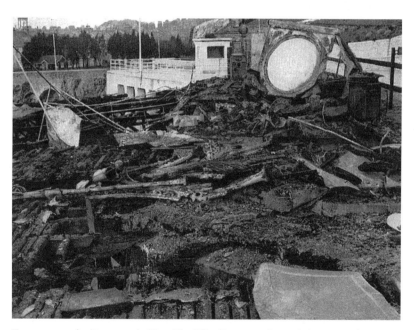

Entrance to the Promenade Pier. The War Damage Commission agreed to meet the costs of £4,754 for demolition of the pier and work commenced in April 1953. The job was carried out by Eglinton Brothers of Plymouth and divers were sent below water to unbolt the many cross-members. The job was completed in September 1953.

The Hoe Slopes. During the bombing on the night of 5 July 1941, the Hoe area came under attack. Bombs were also dropped on Hartley, Crownhill, Keyham, Laira, Devonport and Beacon Park on that night. Near the Hoe, the Windsor Arms and nearby houses received direct hits. Two families were completely wiped out. The explosion was so violent that it threw one man over the tree tops and his body was found 300 yards away.

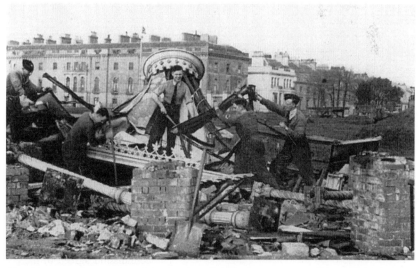

Clearing away the remains of the bandstand for salvage. Here, a barrage balloon crew clear away what was left and also sort out anything that can be salvaged for the war effort. Unfortunately, the bandstand was never rebuilt and the land where it stood was just grassed over.

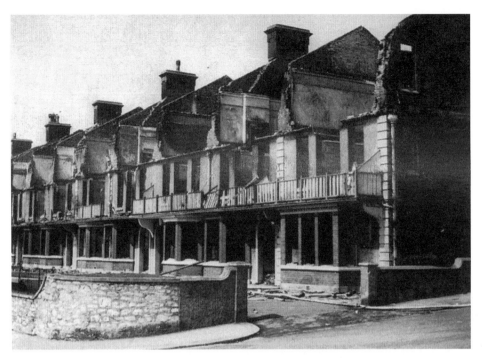

The Terrace on Plymouth Hoe. On 10 July 1940, bombs dropped on Exeter Street and the Hoe district killing five people and injuring seven. Three people were killed near the Hoe where there was damage to large residential properties at Leigham Terrace and Carlisle Avenue. Civilians felt more terror as they were machine gunned by the planes as they ran for the shelters. Luckily, no-one was hit.

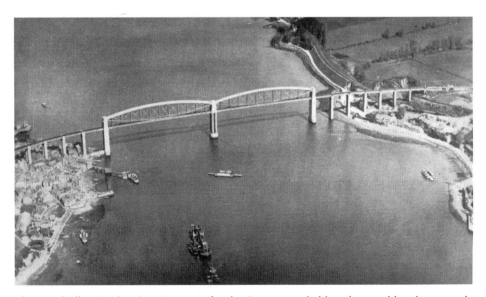

The Royal Albert Bridge. A major target for the Germans and although several bombs narrowly missed the bridge itself, it remained intact. An artillery barge was hit though causing severe damage to the Saltash Passage area and killing several people.

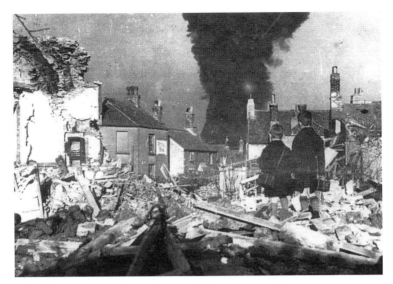

Two boys looking at the bomb damage at Turnchapel. On 27 November 1940, at about 7.30 p.m., an enemy aircraft dropped four flares over the Mount Batten and Turnchapel areas. Almost straightaway, one of the hangars at RAF Mount Batten was hit by a high explosive bomb. There was another direct hit on the Admiralty Oil Fuel Depot opposite Turnchapel station. The fierce fire that followed so illuminated the sky that people on the Barbican and the Hoe could easily read their newspapers in the dark.

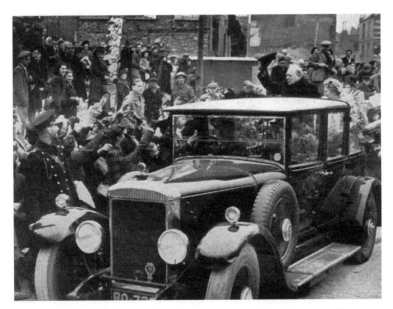

Winston Churchill tours the city on 2 May 1941. Churchill spent a long time touring the devastated city and he was deeply moved by what he saw. Lady Astor told Churchill, 'It's all very well to cry, Winston but you've got to do something!' His visit brought little improvement to the lives of the people living in Plymouth but it vastly improved morale.

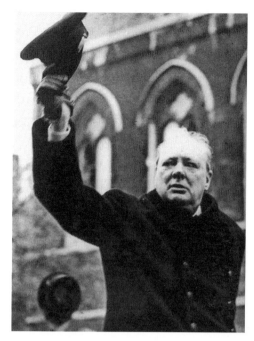

Winston Churchill in front of the Guildhall. Churchill was visibly upset as he toured the city on 2 May 1941. 'Your homes are down but your hearts are high!' he told the people of Plymouth. His visit greatly boosted people's spirits as he toured street after street of destroyed homes and businesses.

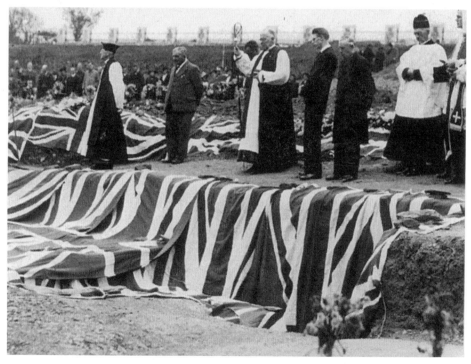

Mass grave at Efford. After the heavy bombing over the two nights of 20 and 21 March 1941, Naval ratings from HMS *Raleigh* were given the grim task of recovering the 292 bodies from the ruins. Lord Astor requested that if he was killed during enemy action that he should have no special ceremony and be buried alongside his fellow Plymothians.

Three

Civil Defence

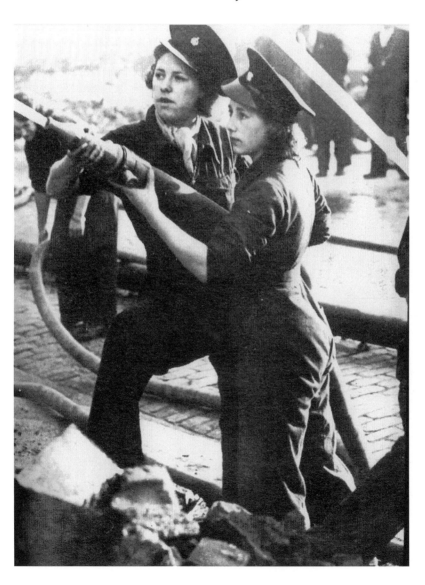

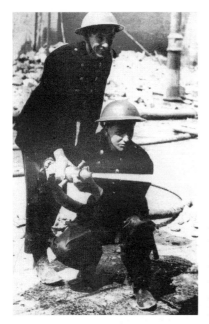

Fire fighting practice. The greater part of Plymouth burnt to the ground during the Blitz of March and April 1941 because the local brigades had inadequate resources to tackle the many fires that broke out. Many brigades from other parts of the country rushed to Plymouth's aid but then found that their equipment wasn't compatible with that of the City's. This led to devastating consequences and many of the brigades had to stand idle.

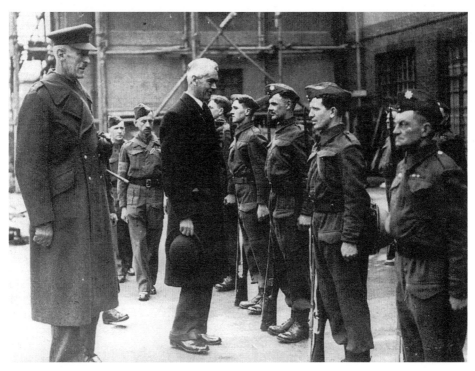

Home Guard Inspection. Between April and May 1941, there were 330 full-time wardens and 1,406 part-time wardens. During just five nights in April, the casualties in the Civil Defence included 40 killed and 120 injured. In 1941, an order stated that all males between the ages of sixteen and sixty, if not in the Home Guard or helping with Civil Defence, had to do 48 hours of fire watching duty each month.

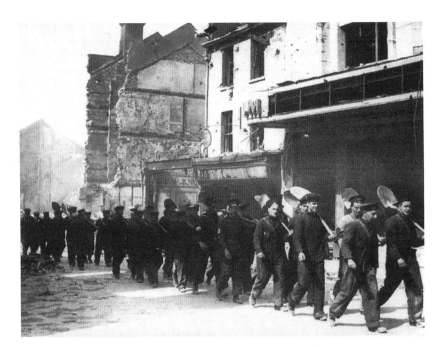

The Navy lends a hand with clearing up. Here, they can be seen in Fore Street, Devonport, just about to pass the remains of the Forum Cinema. The Navy, when land based, also helped women of the WVS cook stew for the many homeless people.

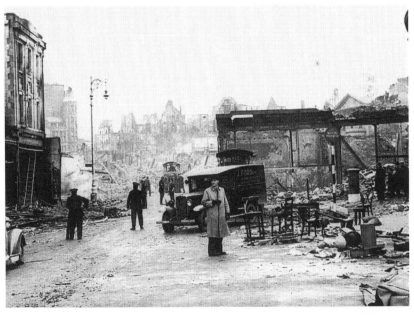

Firemen and a civil defence worker deal with the aftermath of the previous night's bombing here in George Street. Furniture is salvaged from the surrounding buildings and left waiting to be collected and reused while a bulldozer clears away in the background. The van belongs to J. Ford who was a plumber situated in Tavistock Road.

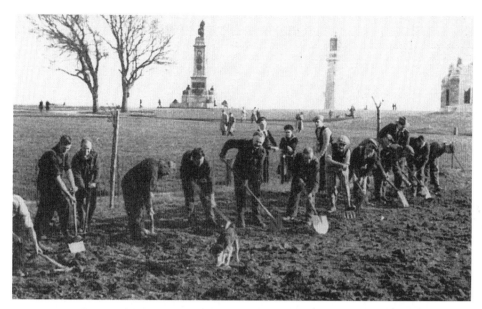

Digging for Victory on Plymouth Hoe. With food shortages, many of Plymouth's city parks were turned into allotments. Here the crop is potatoes. Vegetables were not rationed but were often in short supply. People who had gardens were encouraged to plant vegetables instead of flowers.

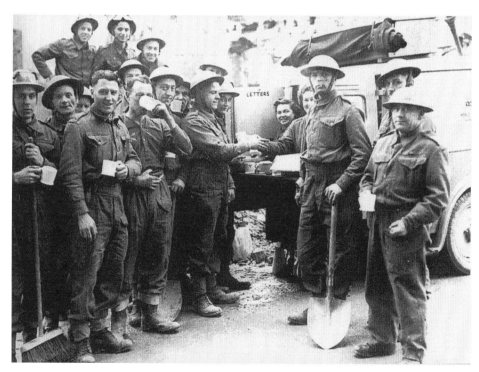

The YMCA provide tea for the troops. The British YMCA played a big part in both world wars providing food, drink and writing materials from special YMCA huts. Their canteen was open twenty-four hours a day supplying meals to the armed forces.

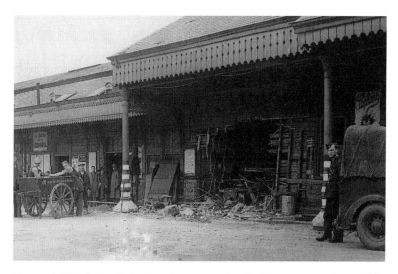

Plymouth North Road Station, frontage and refreshment room. On 21 July 1940, North Road Station was the target during a series of five raids. It was completely missed but bombs hit York Place and did extensive damage and also killed an elderly woman and a young boy. Another bomb hit the premises of Edmund Walker, a ball bearing specialist, in Albany Ope and extensive damage nearby made many families homeless.

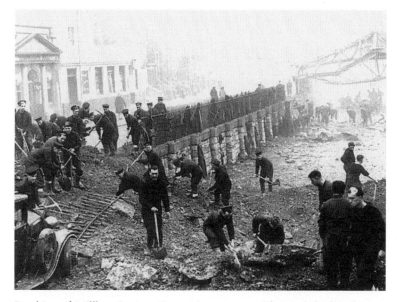

Bombing of Millbay Station. On 27 August 1940, Plymouth had its longest alert so far during the night with relays of German planes heading North. Bombs were dropped over a scattered area including Millbay, Crownhill and Ford. The worst incident was when a bomb dropped on Ford House, the Public Assistance Institution. Thirteen inmates were killed and many others were injured. One young boy was saved when a nurse shielded him with her body. She was knocked unconscious but later recovered.

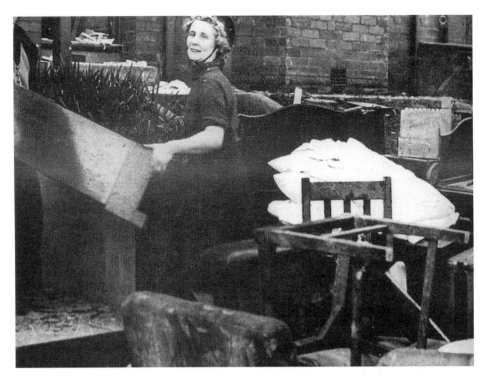

Women salvage workers. Here, furniture has been salvaged from a house to be saved and stored away for safe keeping. Unfortunately, a lot of the saved items were later destroyed in further bombing attacks. A WVS Housewives' Section was formed in 1942. Some women with small children or other commitments didn't have time to do regular WVS work so the Housewives' Section helped by assisting the local warden and making cups of tea and helping the elderly.

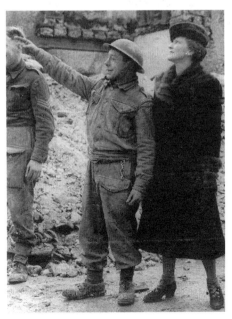

Lady Astor inspects the bomb damage accompanied by a soldier. Lady Astor was born in America in 1879. She married Waldorf Astor in 1906 and they lived at 3 Elliot Terrace on the Hoe. She was the MP for Sutton from 1919 to 1945. During the Second World War, Lord and Lady Astor were the Mayor and Lady Mayor of Plymouth. She died in 1964.

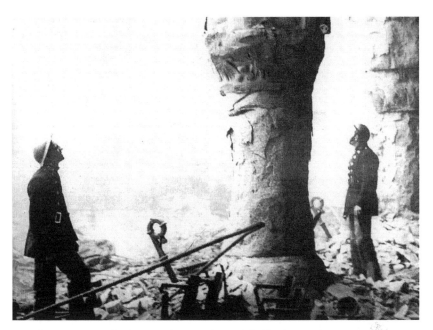

Two firemen survey the damage done to the Guildhall. The Auxiliary Fire Service was formed at the beginning of the war to assist the regular fire brigades. Many of the ranks were made up of women and throughout the country, there were 32,200 women serving in the National Fire Service. Many were part-timers, men were on duty every fourth night and women every sixth night.

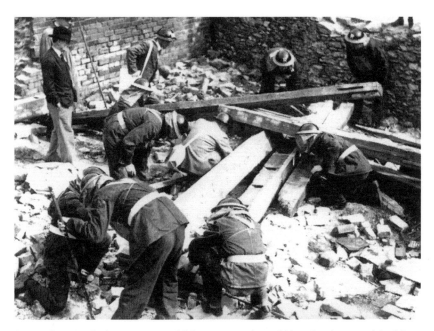

A search is made for any sign of life amongst the rubble of a destroyed building. Civil Defence workers were a liaison between Navy, Army, Air Force and the civilian population. The Town Clerk, Colin Campbell, was controller of the ARP.

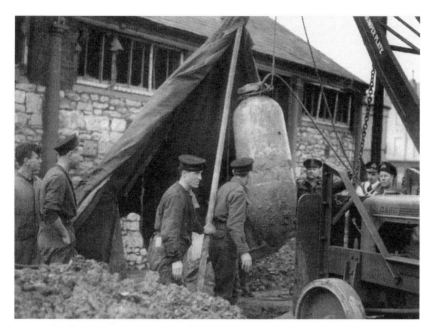

Bomb Disposal squad. On 11 January 1941, the Wolsdon Street bomb, which was one of the biggest unexploded bombs dropped on the city, was removed by the disposal squad. It had been there since the raid of 28 December 1940. It weighed over a ton and was 9 feet long with the fins adding another 2 feet.

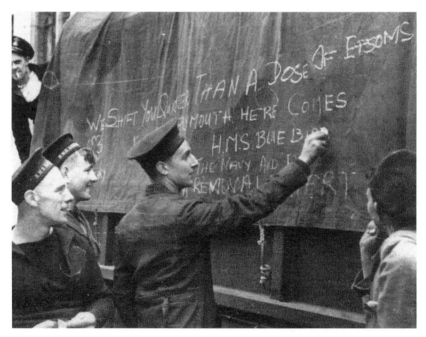

The Navy helping with moving salvaged furniture and belongings. On the side of the lorry, it reads, 'We shift you quicker than a dose of Epsoms!' All salvaged furniture was carefully labelled before storing so it could be traced back to its owners.

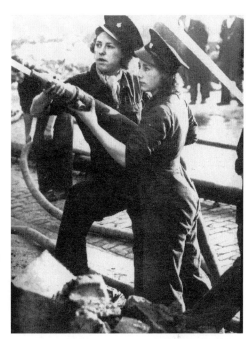

Women salvage workers help man the hoses. In June 1938, the Women's Voluntary Service for Air Raid Precaution was formed. To begin with, the membership was essentially middle class and their uniforms consisted of bottle-green coats and hats which the volunteers had to pay for themselves.

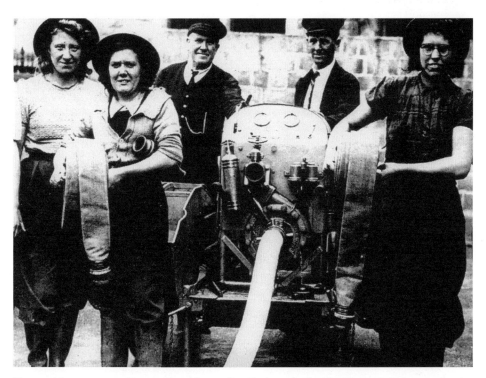

Plymouth's women ready to extinguish any fire. Early tasks for the Women's Voluntary Service included evacuation and making medical supplies such as bandages (from old sheets), pyjamas and nursing gowns. In February 1939, with their roles ever expanding, they became the Women's Voluntary Service for Civil Defence though they were known more commonly as WVS.

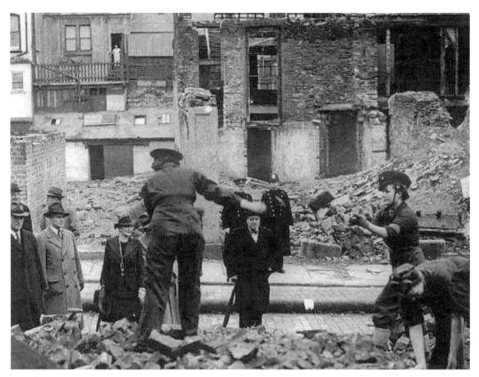

Lady Astor looks on as women salvage workers clear the rubble. Noël Coward said of Lady Astor, 'Nobody who saw Lady Astor, as I did, when Plymouth was being bombed almost out of existence, could feel anything but profound and affectionate admiration. I remember in 1942 walking with her through the streets after a bad blitz. She dashed here, there and everywhere, encouraging, scolding, making little jokes. In the sitting room of one pathetic house, the roof and kitchen of which had been demolished, she ordered a pale young man to take the cigarette out of his mouth, told him he would ruin his lungs and morals with nicotine, slapped him on the back, and on we went.'

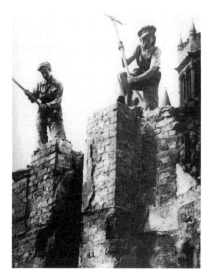

Salvage workers help to demolish the ruins. The Women Voluntary Service were responsible for organising salvage drives which included the removal of railings. They also collected aluminium pots and pans, jelly moulds, kettles, paper and rubber and even artificial limbs. Much of this was never re-used but the drives brought people together and raised morale.

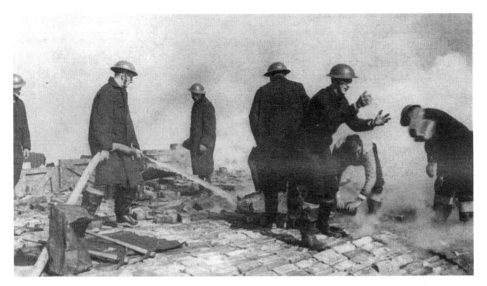

Here, a building is hosed down to stop the fire spreading while others clear away bricks and rubble. The great heat generated from these fires could easily ignite adjacent premises. In August 1939, with war approaching, the Auxiliary Fire Service were issued with tin helmets, their red fire engines were repainted grey and all members were summoned to their stations.

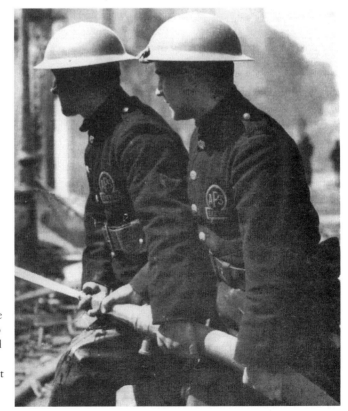

Fire fighters hose down another bomb-damaged building. Fire fighters' resources were so stretched that many fires couldn't be reached and eventually just burnt themselves out. Here, fire fighters from Exeter help out. Fire fighters from all the surrounding districts were called upon to assist with the impossible task of quelling the fires.

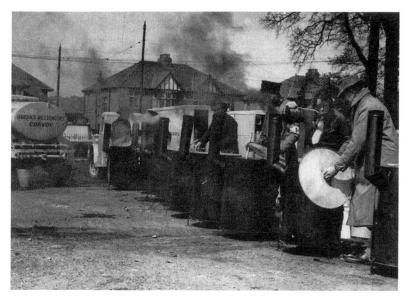

The Queen's Messengers Convoy ready with hot food. These were a familiar sight and were set up to feed the homeless and supply warm food and drink to people without electric and water supplies. The Queen's Messenger Food Convoys were named after Queen Elizabeth (the late mother of today's Queen Elizabeth II) who donated money for the first eighteen convoys.

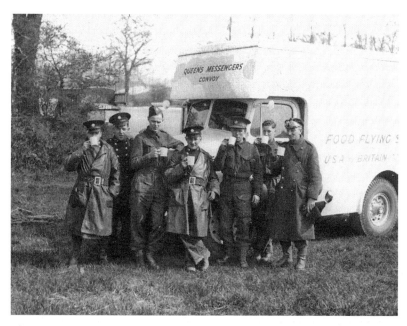

The Queen's Messengers at Central Park. Here, a group of firemen enjoy a well deserved mug of tea delivered by the Queen's Messengers Convoy. The side of their van reads, 'Food Flying Squad USA to Britain'. The Flying Squad was supplied by the American Committee for Air Raid Relief to Great Britain.

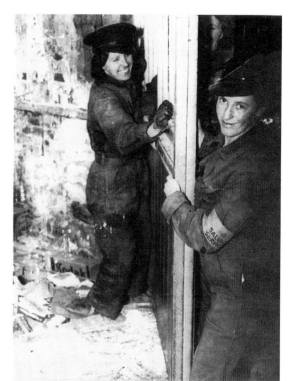

Girls of the Salvage Service. Everything was in short supply so as much as possible had to be saved. On the floor is a Kodak box with many photographs strewn around so perhaps this was the premises of one of Plymouth's many photographers.

A barrage balloon lands on the Strathmore Hotel in Elliot Street. A crowd has gathered to watch the spectacle near to the Bedford Hotel. Barrage Balloons were used for low level defence against enemy attacks. In 1938, Balloon Command was set up with the task of creating large balloons to protect major cities and installations within Britain.

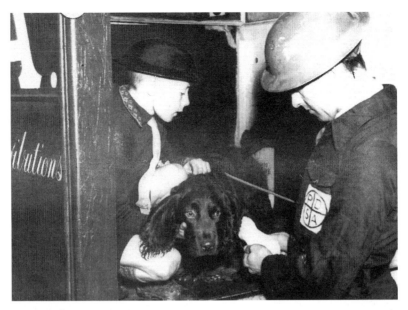

The Animal Rescue Squad. Maria Dicken founded the PDSA in 1917 to provide care for animals whose owners couldn't afford their vet's bills. The PDSA had their own animal rescue squad that worked along side Civil Defence Workers. Many animals were trapped and injured during the Blitz and dogs were used to find them. Many animals were awarded the Dicken Medal which the press called, 'The Animals' VC'.

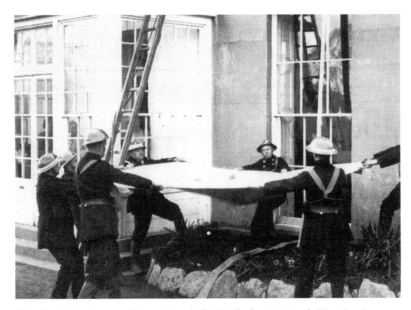

The fire brigade practising their drill. Until the National Fire Service was reorganised in the middle of 1941, fire brigades were a local concern. This meant that the fire brigade was part of the police force and came under the command of the Chief Constable and the City Council. It was completely efficient for normal fire fighting but totally unequipped for the devastation caused by the Blitz.

Four

The People

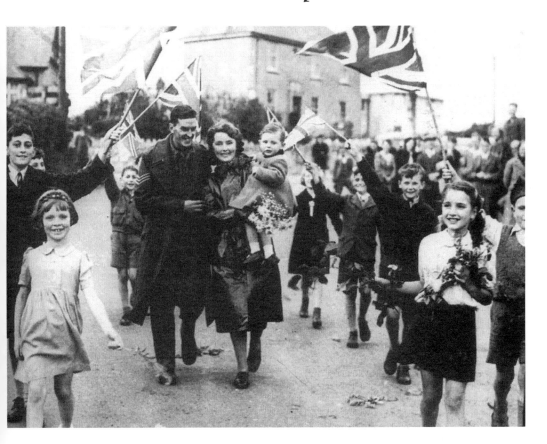

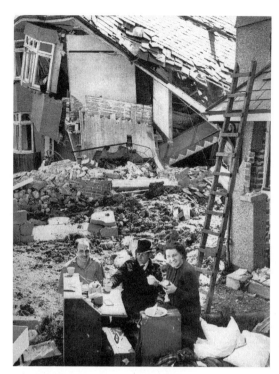

After an air raid at Oreston. This family still find time to smile and have a cup of tea as houses lie in ruins around them. They are surrounded by the few possessions they've been able to rescue. On 28 November 1940, Oreston was bombed along with Turnchapel, Plymstock, the Cattewater and the Barbican. Ten people were killed at Oreston and four houses were destroyed.

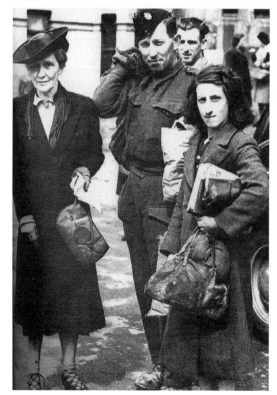

A soldier and his wife with Lady Astor. The Astors regularly visited the various shelters set up around the city for people who had lost their homes. She wrote to one friend, 'Plymouth looks like Ypres – only worse. There is so much to do that I sometimes think I'll be here forever.'

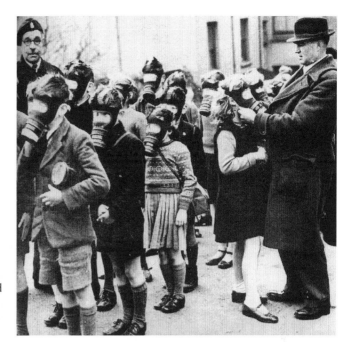

Gas mask drill for children. All children were issued with gas masks which came in small cardboard boxes. Everyday at school, they would have a gas mask drill. Many children found the drills hard to take seriously and their masks were a source for fun and games.

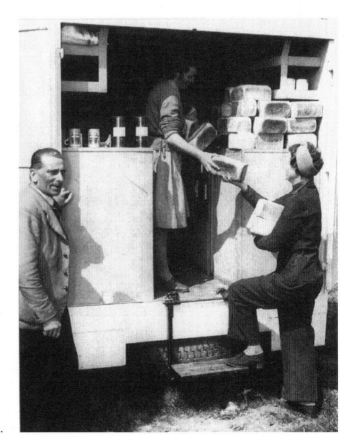

The Queen's Messengers at Home Park handing out loaves. The Messengers were a lifeline to the many people who found themselves without homes, food or possessions. Originally called the 'Food Convoys', they consisted of a few vehicles supplied with bread, basic food stuffs, water and a field kitchen.

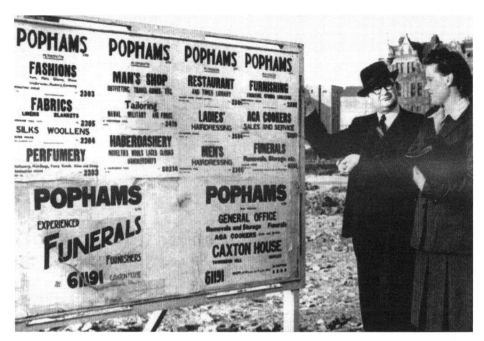

Popham's advertising their wares after being bombed out. Before the Blitz, shops such as Popham's, Dingle's, Spooner's and Yeo's were all located in large adjoining buildings but after the bombing they were found operating in small shops from Mannamead to Drake Circus.

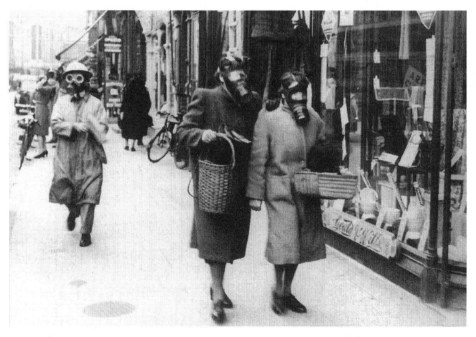

Gas masks on! In September 1942, a mustard gas demonstration was held. The area was roped off to the public and later cleaned up with bleach. However, a day later, two boys playing in the area developed mustard blisters and had to be rushed to hospital.

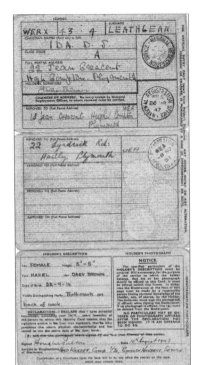

National Registration Identity card. During the Second World War, the ID card was seen as a way of protecting the nation against Nazi spies. By 1952, Winston Churchill's government had scrapped the cards because it was felt they had no practical use during peacetime.

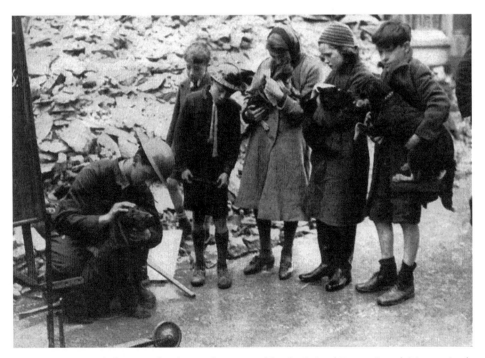

Children queue with their pets for them to be inspected by the Animal Rescue Squad. Many animals were overcome with fright during the raids. Here a vet carefully checks a cocker spaniel while children look on. One boy even has his own tin hat to protect against the falling debris and rubble.

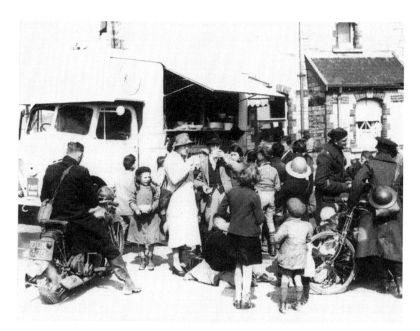

The Queen's Messengers' van draws a crowd at St Budeaux. Many people became refugees in their own city. They had no homes to go to during the day and would spend their time in rest centres. Many would travel out into the countryside at night time to get away from the bombing and sleep in lorries, lanes or farms. In the city, the Queen's Messengers would make sure that they were well fed and had hot meals.

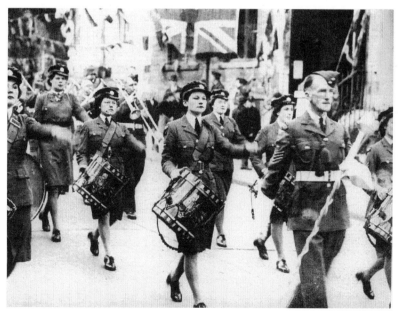

Armed forces proudly marching through the city. Parades boosted morale and many organisations including the Civil Defence, Navy, the Home Guard and the Woman's Voluntary Service all took part. Here, a band plays as it leads the march.

Land Army girls marching past the City Museum. By 1940, agriculture had lost 30,000 men to the British Army and another 15,000 to other vital work. The severe shortage of labour prompted the government to form the Land Army. By 1944, there were over 80,000 women working on the land doing anything from milking and general farm work to cutting down trees and working in saw mills.

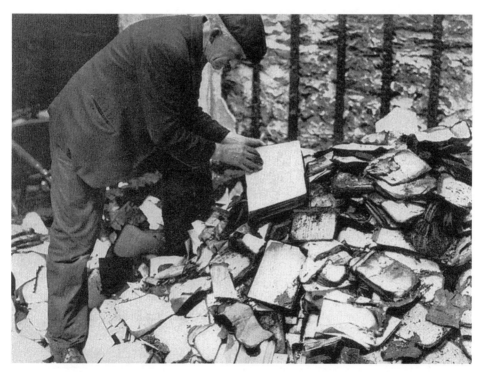

A man rummages through burnt books after the central library is destroyed. The library was opened on 25 October 1910. On 22 April 1941, the building and its books were severely damaged by bombing. Some books were rescued but most were destroyed in the fire. In August though, the Lord Mayor, Lord Astor, reopened the library on a temporary basis, in the museum.

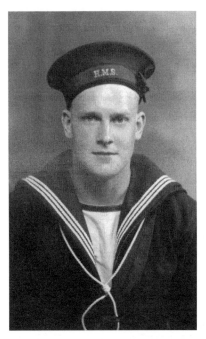

A young Plymouth sailor *c.* 1941.This photograph was taken at Bayley's Studios in Plymouth. The names of 23,000 Naval men and women, who lost their lives in both world wars, are inscribed on the Naval War Memorial on Plymouth Hoe. The memorial was unveiled in 1924 and was extended at the end of the Second World War.

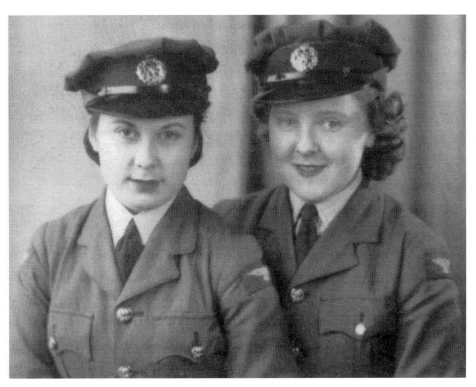

Chris Bailey and Barbara Hill (later Webb) *c.* 1942. Barbara and Chris both served in the WAAF in the Barrage Balloon section. Balloon Command flew barrage balloons to frustrate enemy bombers. By the time the division had closed in 1943, it had trained over 10,000 RAF and WAAF operators.

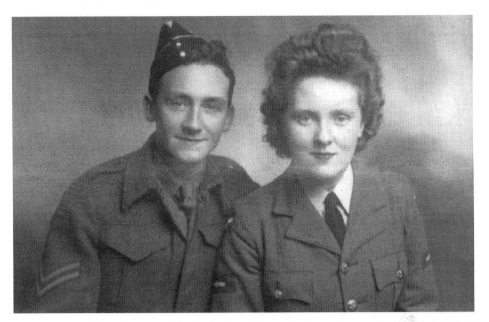

Eric and Barbara Webb pictured on their first wedding anniversary in 1945. Barbara had worked at Dingles in Bedford Street. Upon its destruction, she joined the WAAF Barrage Balloon Section in 1941. She was demobbed in 1946.

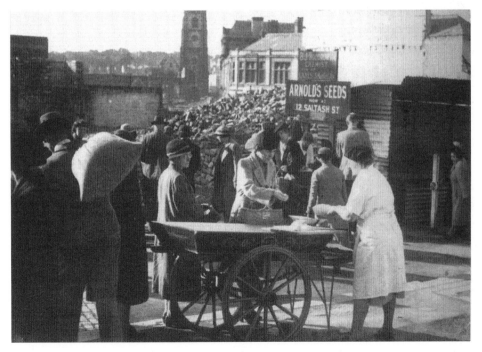

A trader operating from a hand cart. With many buildings destroyed, businesses carried on as best as they could either setting up in smaller premises, which sometimes included someone's front room, or in makeshift Nissan huts.

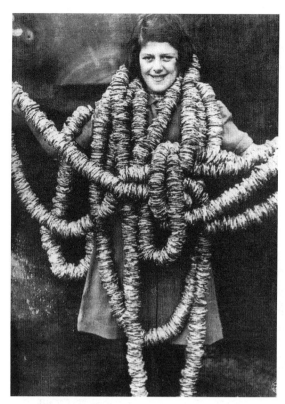

A girl with collected milk bottle tops. Anything that could be salvaged was salvaged, and milk bottle tops were collected for their aluminium to make Lancaster bombers. How many were needed to make one Lancaster bomber isn't known though!

MINISTRY **MF** OF FOOD

RATION BOOK

JULY 1943 ISSUE

Surname... _HUGHES_

Other Names... _Charles J_

Address...
(as on Identity Card)

IF UNDER 18 YEARS

State date of birth (Day)(Month).......... (Year).........

NATIONAL
REGISTRATION
NUMBER _CJYO_ _50_ _1_ GENERAL

IF FOUND RETURN TO

L24

FOOD OFFICE

AH 722060

A ration book. Rationing started in January 1940 firstly with bacon, sugar and butter. Before the war, 55 million tons of food were imported into Britain from other countries. After 1939, the government had to restrict the amount of food coming into the country because the British supply ships were being attacked by German submarines. Rationing of food lasted until July 1954.

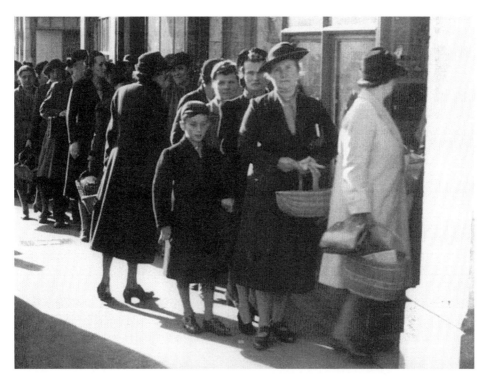

Queueing for rationed food. Huge queues would form for any kind of food that became available. Even a vague rumour could get a queue forming. Fruit wasn't rationed but was in very short supply. Exotic fruits such as bananas were rarely seen and there are stories of people not knowing what to do with them when they did get them. Some people were said to have not known about peeling them and eaten the whole lot, skin and all.

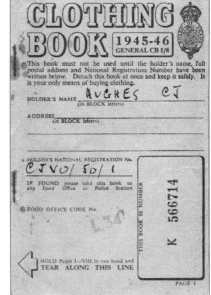

A clothing ration book. Clothing was rationed from June 1941 and people were issued with booklets containing clothing coupons. People were told to 'make do and mend' so that clothing factories and their workers could instead produce munitions.

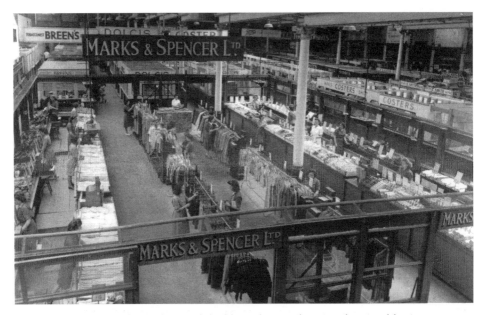

Major shops set up in the market. With buildings destroyed, major shops and businesses set up in the Pannier Market. The market was equipped with new stalls which were rentable at 3*d* per foot per day. Prominent in the market were household names such as Woolworth's, Marks & Spencer's, Coster's and Boots. On a busy day, over 30,000 people would flock to the market.

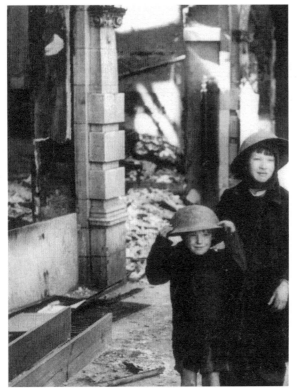

Two boys try on helmets that they've found amongst the blitzed debris. A favourite pastime amongst children would be to search for souvenirs among the rubble. Helmets or other military related items would be sought after but it could prove a dangerous hobby with unstable buildings and many unexploded bombs lying around.

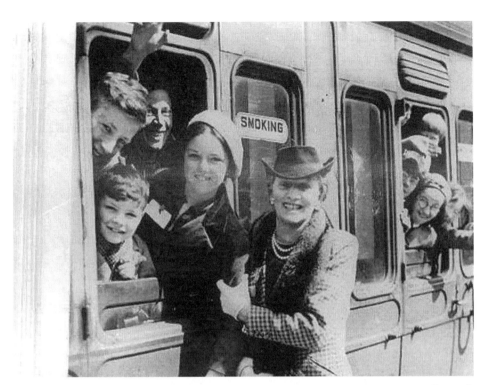

Lady Astor waves off evacuated children. Special trains took hundreds of children off to safe places in the country away from the bombs. Parcels were packed for the children and sent on. These included Wellington boots and warm clothing.

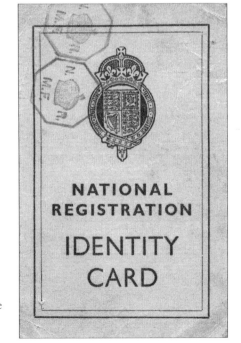

NATIONAL
REGISTRATION

IDENTITY
CARD

A child's identity card. Both children and adults had to carry ID cards. Adults carried blue cards and children carried cream ones. If children became separated from their parents or if their houses were bombed, it was an ideal way for the police to discover who was who and hopefully return them safely to their families.

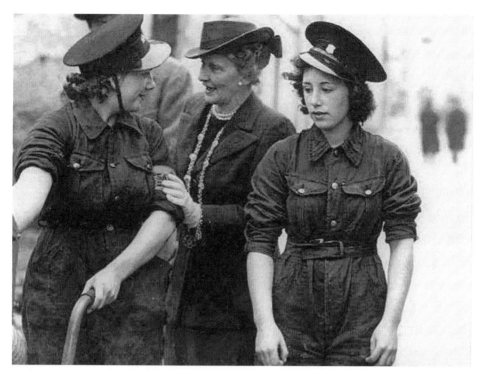

Lady Astor talks to two workers. Lady Astor was well known for her straight to the point way of talking. She had once said to Winston Churchill, 'If I was your wife I would give you poison!' to which Churchill replied, 'If I was your husband, I'd drink it!'

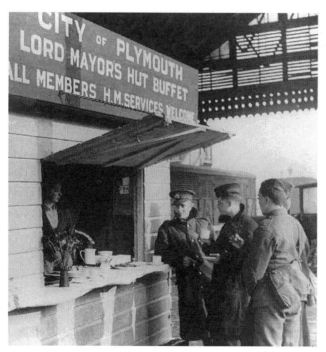

The Lord Mayor's Hut Buffet at North Road Railway Station. All members of The HM services were welcome and could expect something warm to eat and a cup of tea. Work had started on rebuilding the station in 1938 but this had been interrupted by the war and had to wait until 1956 before the work was restarted.

Lord Astor shakes the hand of a small boy as he's evacuated at Plymouth station. The boy has a luggage label tied to him with all of his details. In his bag in his right hand is probably a 'mickey mouse' gas mask. In his left hand, is all the baggage he'll need when he arrives at his new home.

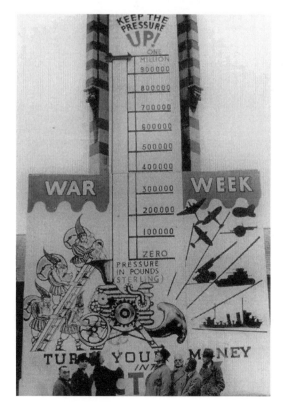

War week. The slogan reads, 'Turn Your Money Into Action'. The target at the top of the hoarding was one million pounds, a huge amount of money today but a colossal amount then. There were regular War Drives to raise money to help finance the war effort.

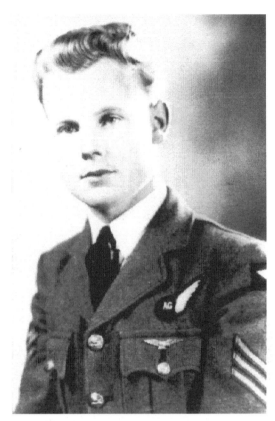

Jim Davis aged eighteen. During the war, Jim served in the RAF as a rear gunner in Lancaster Bombers. He flew thirty-three operations, firstly with 90 Squadron Bomber Command and later with Number 7 Pathfinder Squadron. Jim was later responsible for the creation of the Allied Air Forces memorial on Plymouth Hoe which was unveiled on 3 September 1989.

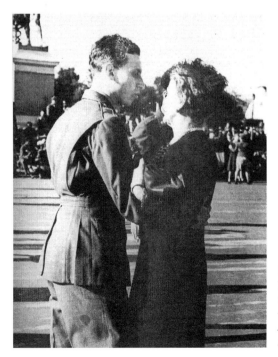

Lady Astor dancing with a soldier on the Hoe. Noel Coward said at the time, 'After all that devastation, on a Summer evening, people were dancing on the Hoe. It made me cry – the bravery, the gallantry, the Englishness of it!'

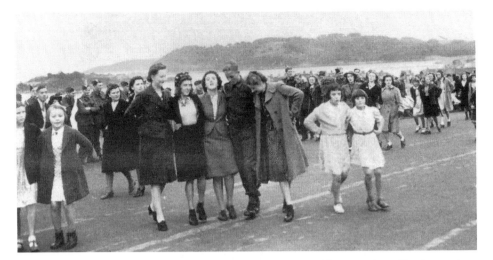

Children dance on the Hoe. Many of them dance in groups as soldiers watch on. The dances drew people together and some people travelled from out lying areas to join in. In the background can be seen Drake's Island and to the right, Mount Edgcumbe.

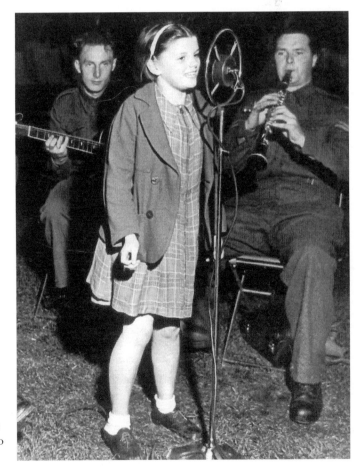

A young girl sings with the army band at an open air concert on the Hoe. The dances continued for many years, though when they started, the bandstand was still in position. A huge dance was held on the Hoe to celebrate VE Day.

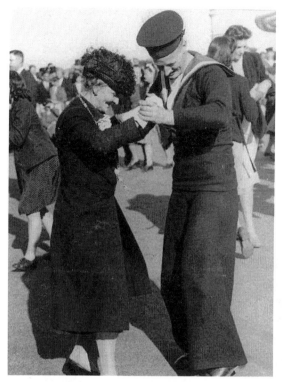

Lady Astor dances with a sailor. Al fresco dancing on the Hoe began in the first week of May 1941. It was a success from the beginning and the idea was first suggested by Lord Astor, the then Lord Mayor. Lady Astor was a frequent participant and among her partners was the Duke of Kent.

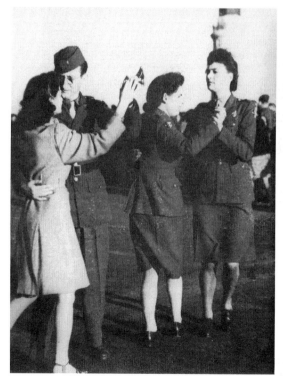

American troops dance on the Hoe. Smeaton's Tower can be seen in the background. This picture would have probably been taken during 1943 or soon after when there was a big American presence in the city.

The King and Queen at Guildhall Square on 7 May 1942. Their six-hour surprise visit was part of their three day tour of Devon and Cornwall. On an earlier visit on 20 March 1941, school children had lined the pavements of George Street, waving small Union Jack flags as the Royal couple's car passed on its way to Guildhall Square. Two days later, the area was blackened and destroyed after the two worst nights of the Blitz.

A soldier is welcomed home. Unfortunately, many young men didn't return from the war and those who did sometimes found their homes or families destroyed. Here's a happy scene where a young soldier is reunited with his wife and child while, what looks like the whole neighbourhood has turned out to celebrate.

Children celebrate Victory in Europe. Here they wave flags around a bonfire. Up and down the country, and around the world, parties were held to celebrate VE day. There was much merriment along with singing and dancing. On 7 May 1945, Germany surrendered and 8 May 1945 was declared as VE Day.

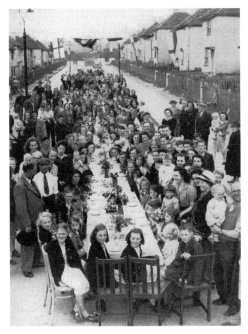

A street party. Here a party is being held to celebrate VJ Day (Victory over Japan).This truly signified the end of the war and there were many parties like this all over Britain. The photograph contains very few young men as they would have all been away in the Armed Forces.

Five

The Americans

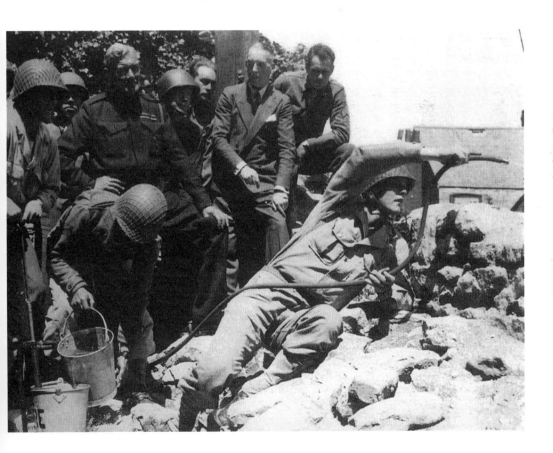

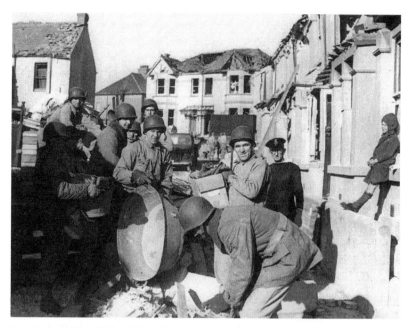

American soldiers help with salvage work. A small boy watches from the right. Children were fascinated by the Americans, their only previous contact with them would have been watching big Hollywood movies at one of the many cinemas around the city.

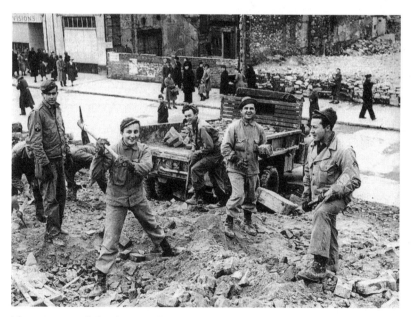

The US troops help clear up the debris. It wasn't until the spring of 1943 that Plymouth first experienced the American Army. They had been stationed in Britain for some time before their presence was felt in the south west. A whole division, the 29th, moved from Salisbury Plain to Devon and Cornwall and set up in barracks which had previously been used by British units.

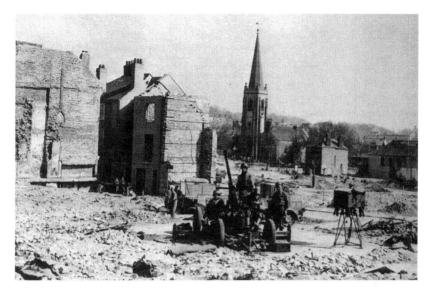

An anti-aircraft gun in the city centre. From 1943, the Americans occupied the whole of Seaton and Plumer Barracks at Crownhill and also Raglan Barracks at Devonport. Eventually, they became more well known on our streets than the British troops. They were well equipped, well dressed and well mannered. They were kept under strict discipline and any misdemeanour was dealt with by their own officers or special courts.

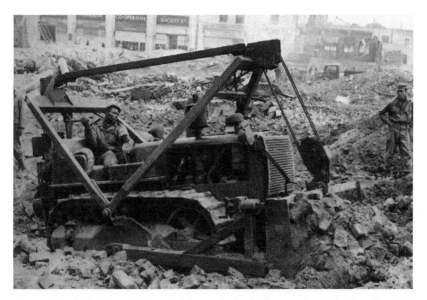

The troops shift the rubble and debris. In the background stands the Plymouth Co-operative building. The Americans were always there to lend a hand. A classic example is the construction of the 250-bed Naval Hospital at Manadon. In just two months, they had built the foundations, the camp and also equipped the hospital with everything it would need. Every section from the nuts and bolts to the stores and equipment came from the US. The foundations had proved a problem at first but these were made from the tons of rubble from the destroyed buildings in the city.

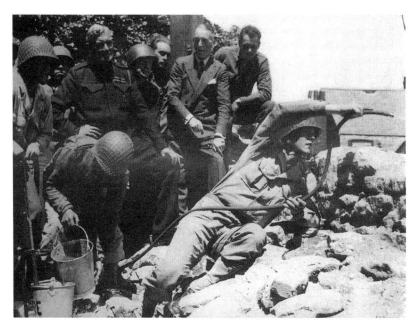

Practising using a stirrup pump. There were so many American troops in Plymouth during and after 1943, that their presence swamped the few British soldiers still in the area. Both soldiers and sailors crowded the streets and shops. They had a respect for Plymouth and its people and for all that they had endured before the Americans arrival.

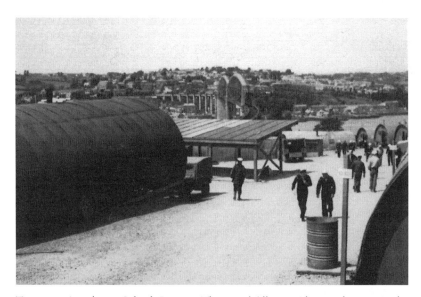

Troops stationed near Saltash Passage. The Royal Albert Bridge can be seen in the background. In January 1944, the US Army set up a camp at Vicarage Road in preparation for the D-Day landings. It housed 60,000 troops on their way to the Normandy landings and operated as a reception centre for returning soldiers from July 1944. It was decommissioned in September 1945.

Maurice Dart near his home in St Budeaux. Maurice remembers the American troops stationed at the Vicarage Road Camp up the hill above the Royal Albert Bridge. Maurice recalls the Americans giving local children sweets and tins of cocoa and he would be told off by his mother when he got home for pestering them!

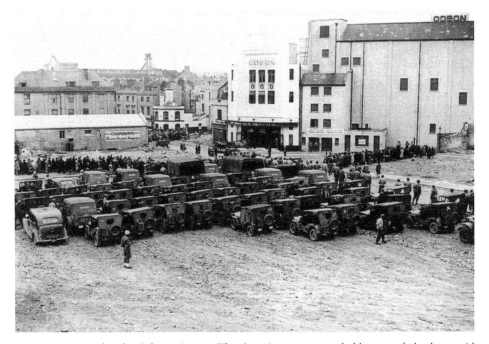

American troops by the Odeon cinema. The Americans were probably one of the best paid armies in the world at the time. They had plenty of money to spend and spent it lavishly. They were remembered for their generosity and friendliness. In December 1943, they threw Christmas parties for thousands of schoolchildren in Plymouth. They would fetch the children from their schools in their jeeps and lorries and then take them back again after the party. The soldiers paid for the parties themselves and as they weren't restricted by rationing, there were plenty of chocolates and sweets and every child came away clutching a toy or a doll.

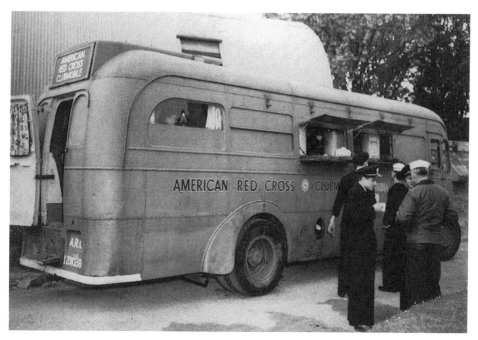

The American Red Cross supplying warm food and tea. The American Red Cross took over five of the large houses in Elliot Terrace, the terrace where Lord and Lady Astor lived, and turned them into a hostel for the troops. Plymouth became an important centre prior to the invasion of Europe and was visited by General Dwight Eisenhower on several occasions. His cavalcade of a large military car and armed motorcycle riders was a sight to see and became quite well known in the city.

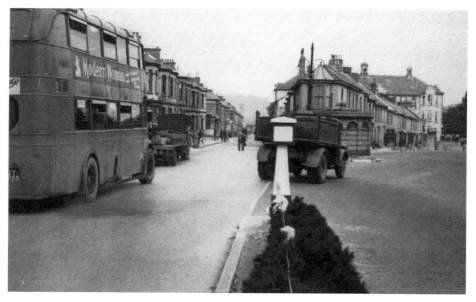

A photograph taken by an American serviceman stationed in Plymouth. On the left is a double-decker bus advertising *Modern Woman* and E. Dingle and Co. on the back. In the distance can be seen Prince Rock on the left and what is now the road to Plymstock on the right.

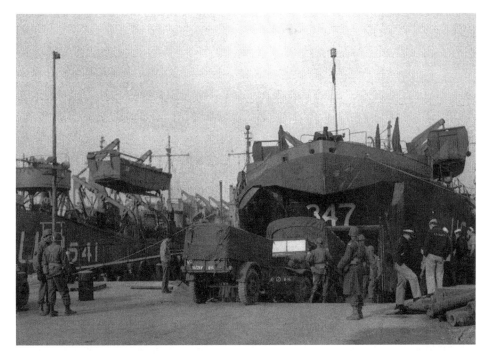

Gifts poured into the devastated Plymouth from America. These included soft toys, food parcels, surgical dressings and ambulances. The Royal Sailors' Rest at Devonport (known as Aggie Weston's) received such enormous crates that they couldn't be fitted into their building.

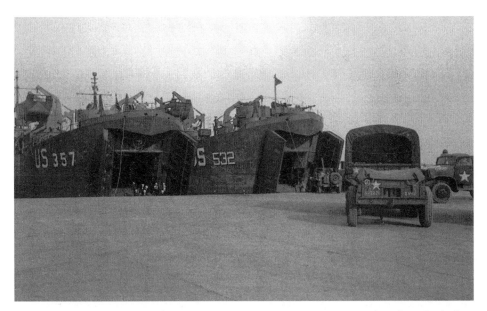

The Americans had their Naval Base at Hamoaze House at Mount Batten but they also had an important Naval Advance Base in the Cattewater where they occupied the whole frontage from Laira Bridge to Sutton Pool. After the Normandy landings, some of America's biggest warships came to Devonport Dockyard for repairs. These included the battleships *Arkansas*, *Texas* and *Nevada*.

This picture shows the captured German Submarine U-1023. Gradually, the American presence within Plymouth grew and it was obvious that Plymouth was to be a major departure point for the invasion of Europe. Their activity could be seen at hards, slipways, wharfs and basins especially in the Saltash Passage and Cattewater areas.

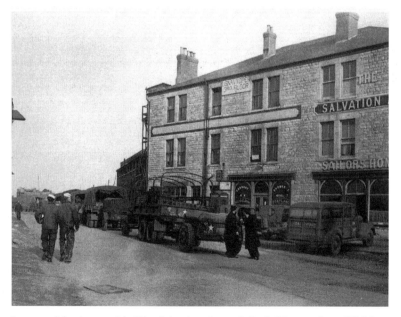

Jeeps and lorries outside The Salvation Army Sailor's Home where US Navy operations were situated on the third floor. The American jeep was a popular sight around Plymouth, a handy vehicle with a four wheel drive. They were left-hand drive but the Americans soon got use to driving on our roads.

Six

Rebuilding

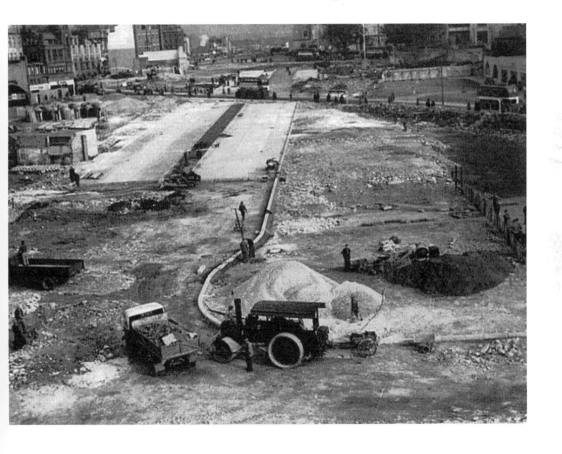

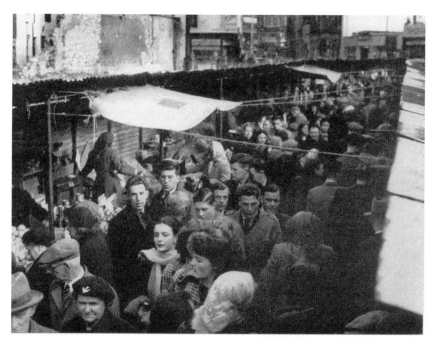

Tin Pan Alley. This was a temporary shopping area adjacent to the market. After their premises were destroyed in the Blitz of 1941, major businesses like Marks & Spencer's and Woolworth's were given prime positions within the Pannier Market while smaller businesses operated from corrugated iron stalls situated in Drake Street.

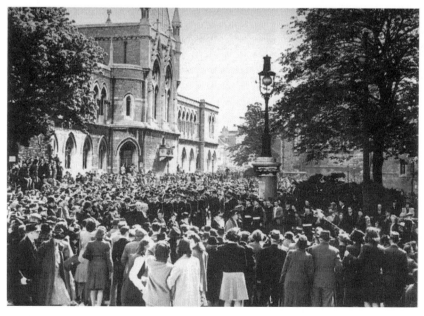

VE day celebrations. Here a crowd gather around the Guildhall to listen to dignitaries and members of the armed forces. The church bells rang out over the city – previously they had been banned except to announce an enemy invasion.

Professor Patrick Abercrombie and Lord Astor. Abercrombie came to Plymouth on 19 October 1941 at the invitation of Lord Astor and the members of the Emergency Committee. He was already heavily involved with the plans for reconstructing London but stayed the weekend with the Astors at their home in Elliot Terrace on the Hoe and commented that the view of the Hoe was the only part of Plymouth that he was familiar with and it's thought that perhaps this is why the Hoe and the grand sweep of Armada Way towards North Hill proved to be the axis on which the new Plymouth was built.

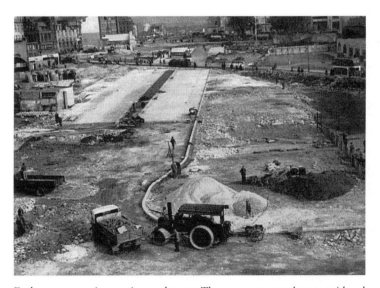

Early reconstruction getting underway. There were many plans considered for the rebuilding of the city. Mr Hansford Worth proposed that the old streets be rebuilt with better access for traffic. Another plan was for the centre to radiate out from the Barbican. In the end though, it was decided that Plymouth should be a more modern city with a central shopping centre with commercial areas and recreational areas with wide roads leading to them.

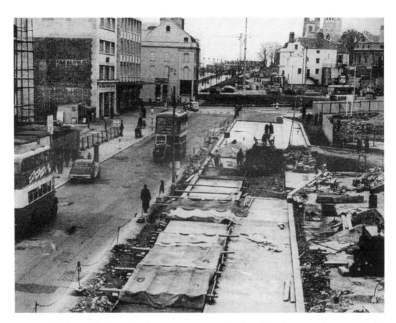

The rebuilding of Union Street. Union Street had suffered major damage in the Blitz especially around the Octagon area. In December 1945, street lamps were reinstated in Union Street, Courtenay Street, King Street and Frankfort Street.

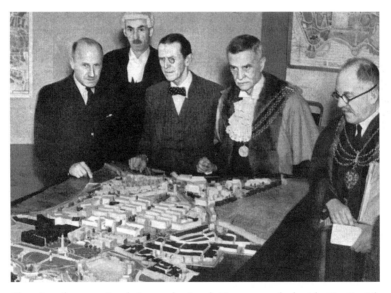

The city planners. Lord Astor, the Lord Mayor stands beside Sir Patrick Abercrombie with his monocle and bow tie. To the left of the picture is Mr J. Paton Watson, the City Engineer. The Plan for Plymouth was published on 27 April 1944. Long before the war had ended, it was realised that Plymouth couldn't be rebuilt as it was before the war. The damage was too severe and long before the Blitz, the roads were already suffering from severe traffic congestion. The proposal put forward was to clear the lot and start again with a modern, spacious city with wide roads.

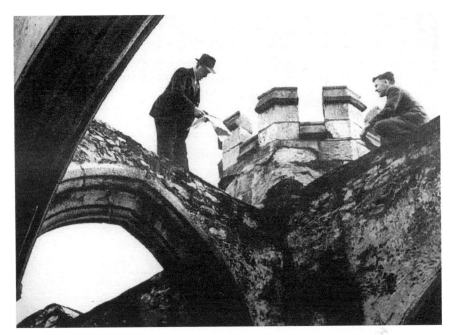

The roof of St Andrew's Church is surveyed. On 22 October 1949, Princess Elizabeth laid a commemorative stone to mark the start of the rebuilding of the church. The roof was later replaced and the church restored by Frederick Etchells.

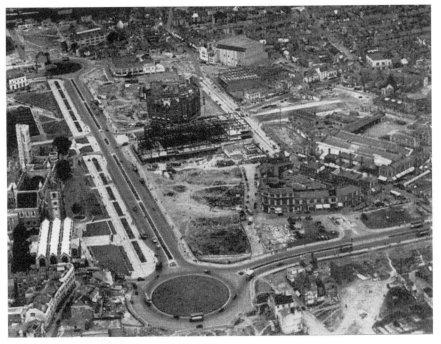

The large stretch of Royal Parade can be seen in this picture though much of the surroundings consist of vast cleared spaces and many of the modern buildings, that we know now, are yet to be built.

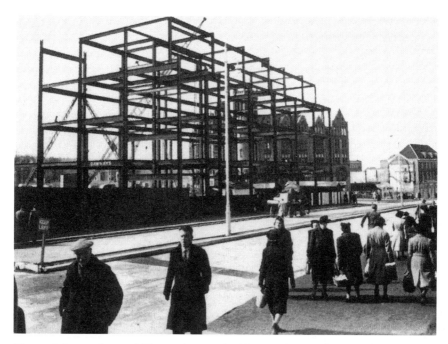

The steel frame of one of Plymouth's new buildings. Taken at the top of New George Street, the *Western Morning News* building can be seen on the right-hand side of the picture and St Andrew's Church can be seen through the steel girders.

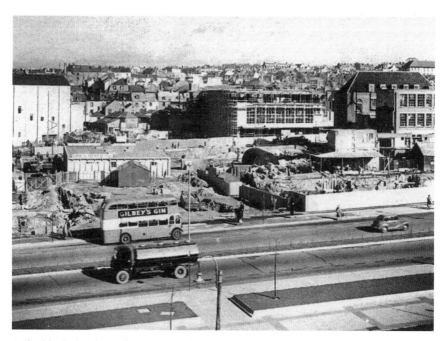

A double-decker bus advertising 'Gilbey's Gin' travels up Royal Parade. Royal Parade suffered its first casualty in 1951 when a Mrs Kathleen May of Fairview Avenue, Laira died after a collision with a bus.

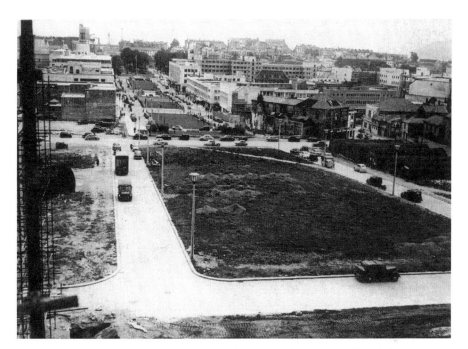

Here, everything is starting to take shape and many of the newer buildings that we know today can be seen in the background. Originally to be called Phoenix Way, Armada Way was intended to be the main boulevard of the new Plymouth.

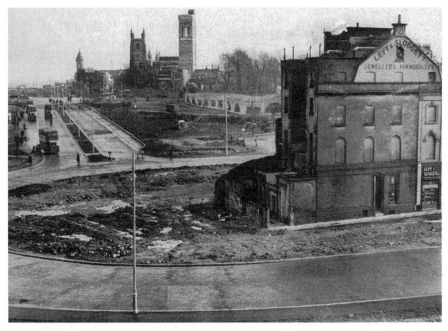

The building in the middle of what is now Derry's Cross belonged to Levy & Sloggett who were jewellers and pawnbrokers. The building was later cleared away and the area grassed over. In the background can be seen St Andrew's Church.

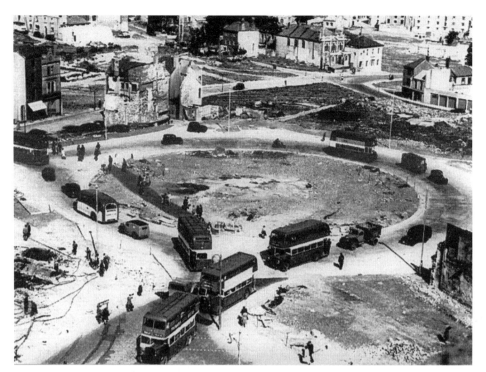

It's interesting to see the many double-decker buses that are travelling towards the heart of Plymouth. The trams are now discontinued, the last one ran in September 1945, though their tracks can still be seen in the bottom left of the picture.

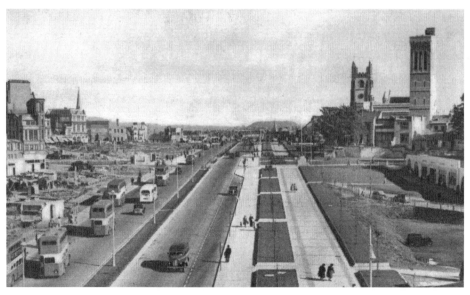

The modern sweep of Royal Parade takes shape though many of the buildings familiar to us today, are as yet unbuilt. Royal Parade was 150 feet wide and clearing and construction of the road began on 4 August 1947. There was a plan to have a roundabout at the junction of Armada Way but this idea was rejected before building work commenced.

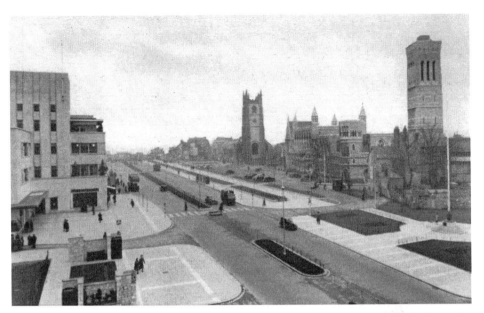

A quiet empty scene with very little traffic. On the left can be seen the then newly-built Dingles building. Dingles opened on 1 September 1951 and 40,000 people visited on the first day. The familiar tower of the Guildhall can be seen on the right and St Andrew's Church is in the distance.

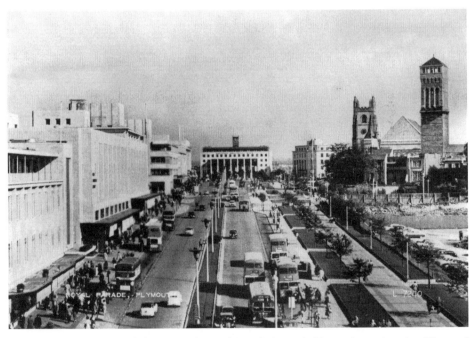

Five years after the end of the war and Royal Parade is much like we know it today. The total cost was £180,000. It was originally opened in two sections. The western end was opened by King George VI on 29 October 1947 and the final part to St Andrew's Cross was opened on 7 September 1948.

Bibliography

Publications
Mike Brown, *Put That Light Out!* (Sutton Publishing, 1999)
Arthur Clamp, *Blitz of Plymouth 1940–1944* (PDS Printers, 1981)
Andrew Cluer and Ron Winram, *Plymouth and Plymothians* (Winram-Cluer Pubns, 1985)
R. F. E. Cock, *Plymouth Blitz* (Unknown Publisher, 1940s)
Jim Davis, *Winged Victory* (R. J. Leach & Co., 1995)
Guy Fleming, *Plymouth Pictures from the Past* (Devon Books, 1994)
Guy Fleming, *Plymouth More Pictures from the Past* (Devon Books, 1996)
H. P. Twyford, *It came to our Door* (1947)
H. P. Twyford, *Plymouth Blitz: The Story of the Raids* (*Western Morning News*, 1947)
Kevin Scrivener, *Plymouth at War* (Archive Publications, 1989)
Gerald Wasley, *Plymouth A Shattered City* (Halsgrove, 2003)
Frank Wintle, *Plymouth Blitz* (Bossiney, 1985)

Newspapers
Evening Herald
Western Morning News

Websites
Boots at www.boots-plc.com
Brian Moseley's Plymouth Data website at www.plymouthdata.info
Steve Johnson's Cyberheritage website at www.cyber-heritage.co.uk

Other books by Derek Tait
Images of England: Plymouth
Plymouth at War
Saltash Passage
St Budeaux
Plymouth Hoe
Mount Edgcumbe
Memories of St Budeaux
Saltash
Plymouth: Tales From The Past
Sampans, Banyans and Rambutans – A Childhood in Singapore and Malaya
Memories of Singapore and Malaya
More Memories of Singapore and Malaya
Monsoon Memories
Plymouth Through Time
Saltash Through Time
Rame Peninsula Through Time